IMAGES
of America

GENERATIONS OF SOMERSET PLACE
FROM SLAVERY TO FREEDOM

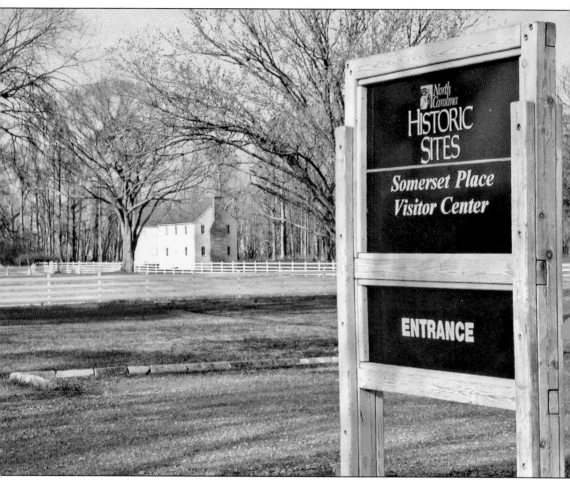

During its 80-year existence as an active plantation (1785–1865), Somerset Place encompassed as many as 100,000 acres in North Carolina and became one of the South's most prosperous rice, corn, and wheat plantations. It was home to more that more than 800 enslaved men, women, and children of African descent—80 of whom were brought to Somerset directly from their West African homeland in 1786. The plantation operated as a business investment for more than 40 years. In 1829, it became home to two generations of a planter family: Josiah Collins III, his wife Mary, and their six sons. When the Civil War ended in 1865, so did slavery in the United States. Left without unpaid labor, the plantation system that had characterized the antebellum South collapsed. After years of neglect and a series of owners, Somerset Place was restored and opened as a North Carolina State Historic Site in 1969.

IMAGES
of America

GENERATIONS OF SOMERSET PLACE
FROM SLAVERY TO FREEDOM

Dorothy Spruill Redford

ARCADIA
PUBLISHING

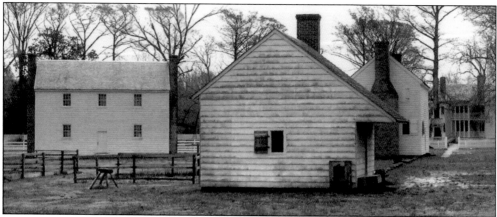

Visitors tour the Collins Family Home and related domestic dependencies, including the dairy, kitchen/laundry, kitchen rations building, smokehouse, and salting house. Reconstructed buildings related to the enslaved community include the Suckey Davis Home, Lewis and Judy's Home, and the Plantation Hospital. Archaeological remains of several other buildings and the Plantation Stocks can also be explored. This photograph shows, from left to right, the Plantation Hospital, Lewis and Judy's Home, the Suckey Davis Home, and the rear wing of the Collins Family Home.

CONTENTS

ACKNOWLEDGMENTS

If "one picture says a thousand words," the more than 200 photographs in *Generations of Somerset Place* speak encyclopedic volumes about the family archivists who cherished and preserved the paintings, tintypes, studio photographs, and snapshots included in this publication.

Abiding honor and gratitude is due the now-deceased contributors who were interviewed during the 1980s to document the history of generations born at Somerset Place before 1865. With open hearts, twinkling eyes, and pride in their voices, these mainly octogenarians lovingly reminisced about their ancestors and shared fascinating stories about everyday life before the turn of the 20th century that they heard as children from their grandparents. They also searched through boxes and trunks for tintypes and willingly lifted the pictures that had been glued down on the pages in family album for decades. Some graciously took their large antique frames down from the living room wall so that the image of a cherished family member could be copied. Among them are Sarah Jane Baum, Ludie Bennett, Clarence Blount, Trumilla Brickhouse, Josiah Collins VI, Lora Lee Fenner, Odessa Cabarrus Harris, Deloris Bennett Pruitt, Mitchell Spear, Louise Littlejohn Spruill, and Margaret Spruill. Special thanks also to the still-living contributors who are now between 90 and 98 years old: Elsie Baum, Henry Bryant, Clara Jenkins Preston, and Moriah Wills. A further debt is due to many others for assistance, including Elna Baum, Country Flair Antiques, Oressa Fenner Fuller, Emma Littlejohn Hope, Frances Drane Inglis, Lona Smith Johnson, Margaret Johnson, Alverita Jones, Barbara Spruill Leary, Alecia Rodgers, Doris Rodgers Owens, Mercedia Pailen, Loretta Phelps, William and Richard Honablue and their sisters Anna Rose Robertson and Doris Honablue Samuels, and all others not specifically mentioned. Thanks also to John Collins Sykes for his sterling research on the Josiah Collins family history.

Over the years, consistent support has come from the Somerset Place Foundation, Inc., as well as historians and curators with the North Carolina Department of Cultural Resources's Museum of History, Office of Archives and History, and Museum of Art, and to Dr. Richard K. Knapp of the Division of State Historic Sites and Properties.

Lastly, for adopting a mission that maximizes new photo-imaging technology and for making books such as *Generations of Somerset Place* available to a broad audience at a reasonable price, thank you Arcadia Publishing. This publication makes photographs of the Generations of Somerset Place available to yet unborn generations.

INTRODUCTION

Family pictures visually document our past, comfort and often fill a void in the present, and inform our future generations. They capture a family's important moments in time, special places and events, and allow us to visit and revisit the close-to-the-heart faces of beloved grandparents and grandchildren over our lifetime. *Generations of Somerset Place* presents the cherished faces and places associated with North Carolina's Somerset Place plantation.

Before the mid-19th century, the faces of Americans that were preserved largely reflected the legal and financial advantages vested in the small fraction of our population who were living on the higher rungs of the socio-economic ladder—and the persuasions and skills of artists. By the mid-19th century, however, photographic imaging became a part of the American vocabulary, and the democratization of image making emerged: black and white, wealthy and working-class families all had affordable pictures taken by professional photographers working out of either permanent or portable traveling studios. Although professional photography still flourished, the full democratization of making images came into its own by the mid-20th century. Someone in everyone's family owned a reasonably priced, hand-held camera, which permitted families to take their own pictures of anything and everything they deemed photogenic, including houses, barns, automobiles, favored farm animals, and, of course, loved ones. *Generations of Somerset Place* loosely presents the images included according to the evolution of various methods of capturing them.

Our photographs are divided into three broad categories and arranged chronologically within each category. The first category, called "Poised and Posed," includes members of Somerset's generations whose images were to some extent staged and shaped by portrait artists, first-generation photographers using first-generation photographic equipment, or more sophisticated photographic artists using the latest evolving technology. The earliest 19th-century portraits are oil paintings, portrait miniatures, and other mediums only the moneyed gentry could afford. By the late 19th century, however, we see for the first time images of African American generations of Somerset Place taken both in studios and by itinerant photographers who brought portable studios to the small towns surrounding Somerset Place. These later images include studio cabinet cards, tintypes, and other studio pictures that are set against studio backgrounds ranging from the exotic to complete blankness. With the 20th century, the era of real-photo postcards (commonly called picture postcards) emerged and remained popular through World War II for Somerset's generations. "Poised and Posed" ends with the fun and inexpensive photographs taken when the carnival paid its annual visit to Creswell, North Carolina.

By the mid-20th century, it seems at least one member of almost every family owned a camera and was staging and snapping family pictures. Among the generations of Somerset

Place, formal studio pictures began to be less popular. The exception may have been the inexpensive photographs taken when traveling carnivals paid annual visits to small rural towns such as Creswell.

Spontaneity best describes the second category, called "Snapshots." The subjects are not formally posed or, for that matter, always centered and in focus. The images do, however, present real-life situations and the people who lived them. Family members and friends who owned cameras snapped pictures that exude love, pride, and a fair amount of humor. Consider, for example, a picture of a youngster riding a goat cart through the streets of Creswell in 1954. Each photograph tells a story and prompts a story from the family members (and even strangers) who see it.

The final category, "Generations of Somerset Place Today," includes a mix of professionally taken photographs and snapshots. These pictures begin in 1986, when more than 2,000 descendants of slaves and slave-owners gathered on the grounds of Somerset Place for a special "Homecoming." The unprecedented and affirming event honored ancestors and celebrated life.

The photographs included represent only a fraction of those taken. Some early tintypes and photos deteriorated over their 60- to 70-year lifespan and could not be used. With out-migration and movement away from Somerset, many family members' photographs have simply been lost. There are also limitations on the number of photographs Arcadia can publish in one book. The pictures that are included contain at least one member of every Somerset family.

Generations of Somerset Place is not meant to be a scholarly offering. It is our family album, which will hopefully document the past and bring smiles and "warm fuzzies" to all who view it. Without question, it will inform our future generations of Somerset Place descendants.

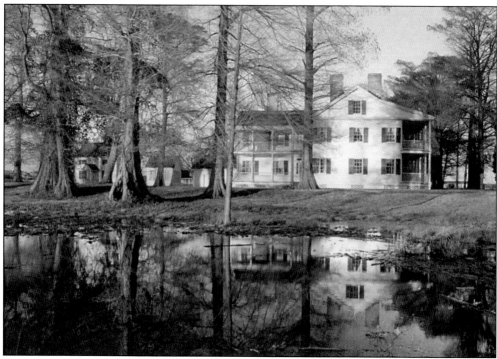

The Collins Family Home is pictured here.

One

POISED AND POSED
1800–1865

A widowed Josiah Collins I (1735–1819) and his two minor children, Josiah Jr. (1763–1839) and Ann (Nancy) Collins Blount (1765–1796), immigrated to America from England in 1773. Collins spent his life in America creating wealth through visionary business ventures and carving out a prominent place for his progeny within the prevailing economic, political, social, and religious institutions of the time. Among his business ventures was orchestrating the transformation of an uninhabited, jungle-like terrain into Somerset Place plantation through the extensive use of enslaved laborers. One copy of this oil-on-canvas portrait, possibly painted around 1810, hangs in the office of the Collins Family Home at Somerset Place.

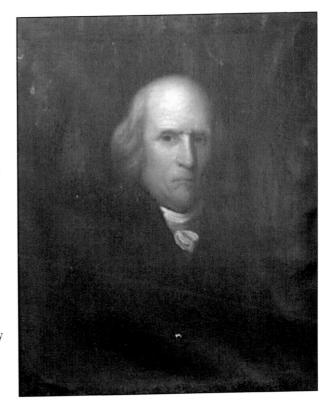

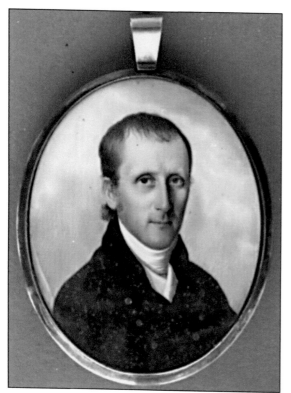

During the 19th century, itinerant miniaturists routinely visited small towns, whose population could not support a resident artist, and offered their services painting miniature portraits of local residents. The images were typically painted on ivory, encased in a frame, and positioned in a special portable display case. Josiah Collins Jr. (1863–1839), heir to the properties his father, Josiah Collins I, owned in Edenton, North Carolina, may have posed for one of the itinerant painters who visited there. His Edenton inheritance included the family home, called the Homestead, where his family lived. Somerset Place passed directly from Josiah I to his eight minor grandchildren with Josiah Jr. managing the plantation until his oldest son, Josiah Collins III, reached adulthood and established a home place for his family at Somerset.

Ann Rebecca Daves Collins (1785–1833), daughter of John and Mary Haynes Long Daves, wed Josiah Collins Jr. in 1803. Over the next 23 years, she gave birth to eight children: Ann Daves Collins Shepard, Mary Matilda Collins Page, Josiah Collins III, Henrietta Elizabeth Collins Page, Hugh Williamson Collins, John Daves Collins, Louisa McKinley Collins Harrison Stickney, and Elizabeth Alethea Collins Warren. Today this ornately framed portrait of Ann Collins hangs in the dining room of the Collins Family Home at Somerset Place.

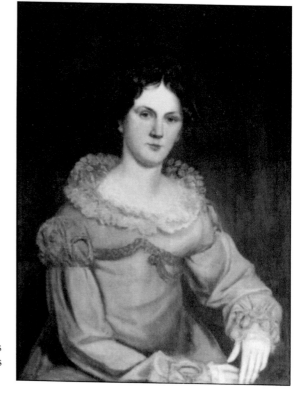

Josiah Collins III (1808–1863) established a family home at Somerset Place shortly after his 1829 marriage to Mary Riggs Collins of New Jersey. By 1860, Somerset Place was the third largest slaveholding plantation in North Carolina. Josiah III and Mary had six sons, three of whom survived to maturity: Josiah IV, George, and Arthur. Two sons, Edward and Hugh, drowned in a Somerset canal, and a third son, William, lost his life in a riding accident. Josiah III directed the construction of a 14-room house at Somerset Place known today as the Collins Family Home. The oil-on-canvas portrait pictured here adorns the wall of his home.

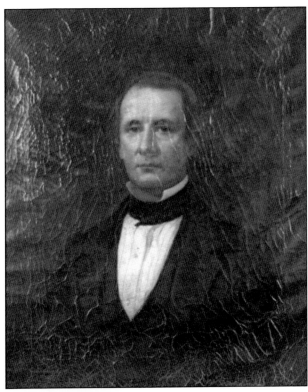

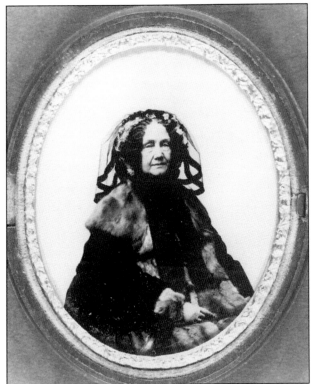

This picture of Mary Riggs Collins (1808–1872) captures the outward appearance of 19th-century women in mourning. The image was probably made soon after her husband, Josiah Collins III, died without warning in 1863. Customarily for at least a year after their husbands' death, women of Mary's social position dressed in black, donned black-trimmed head coverings, carried white silk mourning handkerchiefs trimmed in black, and often wore special mourning pins containing a lock of hair from the deceased loved one. Mary Collins died at Somerset Place in 1872.

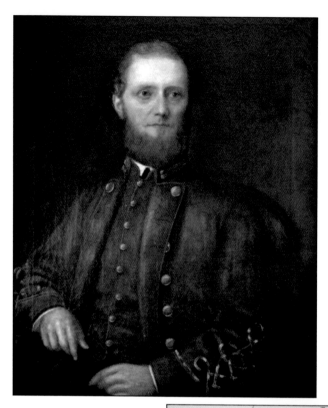

Commissioned a first lieutenant in the Confederate army, Josiah Collins IV (1830–1890) was heir to the Collins Family Home at Somerset Place. When the Civil War ended in April 1865, so did slavery. Nearly all of the former slaves had left Somerset Place to seek a life elsewhere by November 1865. Left without unpaid labor, the Collins family could no longer maintain the plantation. Josiah IV had to rely on his training as a lawyer to support his family. This oil painting (now at Somerset Place) was possibly commissioned after the war using a wartime tintype as the source.

Sarah (Sally) Rebecca Jones Collins (1833–1892) married Josiah Collins IV in 1859 and moved into the Collins Family Home at Somerset Place. Three of their six children were born there: Mary, Josiah V, and Cadwallader. After the Civil War, the family settled in Hillsborough, North Carolina, where daughters Rebecca, Lizzie, and Alethea were born. Sally's fetching and ornately framed, hand-painted, enlarged photographic portrait, now hanging at Somerset Place, documents the emerging shift from oil-on-canvas to less expensively produced family images.

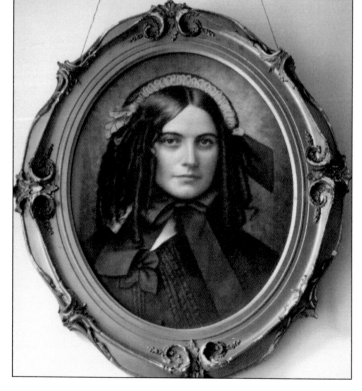

Two

POISED AND POSED
1866–1900

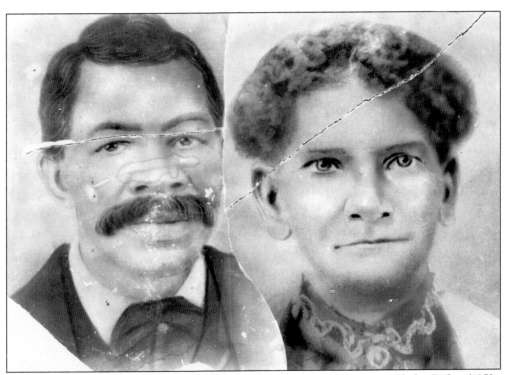

On February 15, 1875, Jupiter Pailen (1833–c. 1910) and his wife Lucreecy Phelps Pailen (1853–1819) paid $80 for a parcel of land in the town of Creswell, next door to his brother George Pailen. Both brothers had been living on the land belonging to the ex-slave Washington Bennett since around 1867. Jupiter was the son of house servants Joe and Rachael Pailen. Married twice, his second wife, Lucreecy, was 20 years his junior. Jupiter is reported as having 16 children, 9 of whom were living when the 1900 census was taken. By around 1885, these fragile, enlarged, and framed photographic images hung in the parlor of their Creswell home.

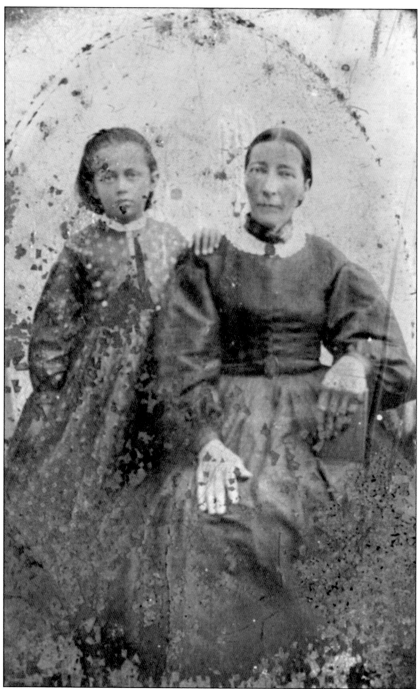

Mahalia Bryant Tarkington (1842–?), wife of James Tarkington, said that she was a full-blooded Indian belonging to one of four known Indian family groups in Washington and Tyrrell Counties: the Bowsers, Bryants, Hills, and Rowsoms. Because their numbers were small, out of necessity they chose spouses from among slaves. This early tintype shows Mahalia around 1875 with one of her five daughters. They are exquisitely dressed in clothing likely made by Mahalia's own hand.

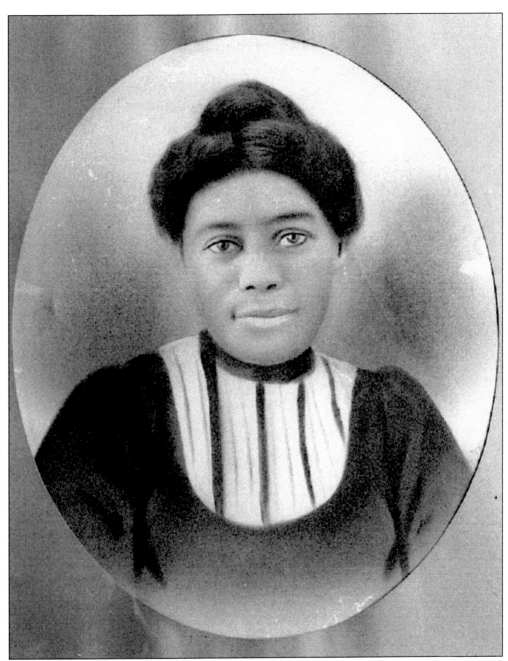

Margaret Murdough (1849–1914) was the only daughter of Somerset slaves David (1820–1902) and Margaret (1820–?) Murdough. Her parents left Somerset Place after emancipation and settled in Edenton—a town cosmopolitan enough to offer more than fieldwork for blacks. By the 1950s, all of her descendants left the South and settled in places like New York and Philadelphia. According to family members, two of her grandchildren moved to Boston where they passed for white. This youthful c. 1870s picture of Margaret is a charcoal enhanced photographic image mounted on canvas and framed in an elaborately crafted frame by Home Art Company in Norfolk, Virginia.

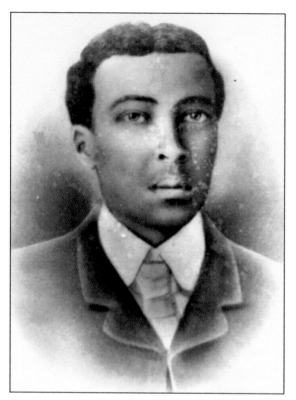

Born at Somerset Place, Ransom Bennett Sr. (1842–1916) was the son of Washington and Jenny Harvey Bennett. In 1867, his parents acquired 10 acres of land in Creswell, and the family started on an enviable path to prosperity. By 1877, Ransom purchased three acres adjacent to his parents' home and erected a "store house where he usually conducts transactions." He also owned "a five year old cow called Emma and her calf; a mare named Fanny, bay in color," and had 15 acres of cotton under cultivation. When the Town of Creswell was incorporated in 1875, Ransom Bennett served as its first mayor. He supplemented his income building "mud-n-stick" chimneys.

Catherine Reeves (Pettigrew) Bennett (1847–1896) and Ransom married in 1866 and started a family that eventually included eight children: Eliza, Henrietta, Ransom Jr., Edward, Johnson, Margaret, Hickman, and Richard. Though married in 1877, Catherine asserted almost unheard-of independence by purchasing an acre of Creswell land in her name and opening her own store. Catherine and Ransom inherited all of the Bennett family land, providing a nice nest egg for their children. But after she and Ransom died, their sons left town to seek their fortune in the North. This 16-by-20-inch early image was colored during the 20th century to show Catherine's blond hair and crystal-clear blue eyes.

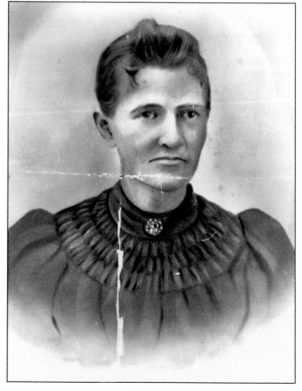

This early photograph is of Melvin (1845–1920) and Catherine (Kate) Collins Dickinson (1848–1918). Kate's grandparents, Guinea Jack and Fanny Collins, were two of 80 native Africans brought to Somerset Place in 1786. She and Melvin, son of Moses and Elizabeth Dickinson, married in Somerset's Lake Chapel on October 20, 1869. After the Civil War, they worked as farm laborers for a time, but by 1875, they had settled a few miles west of Somerset Place in the town of Roper. Melvin traded in long hours in the fields for long hours at the Roper Lumber Mill, and Kate labored in her own fields.

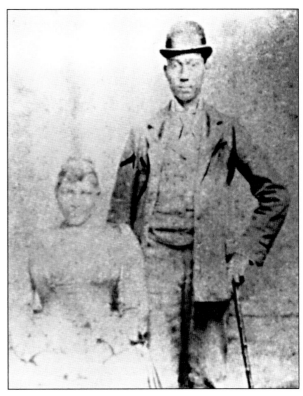

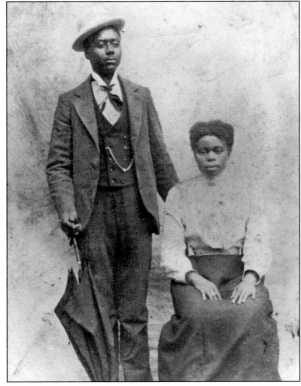

By the 1890s, itinerant tintypists arriving in Creswell just after the crops were sold for the year found an economic bonanza with black and white families alike, especially landowners. James Lemit Cabarrus Sr. (1839–1929) and Augusta Anna "Gustanna" Carter Cabarrus (1846–c. 1909), pictured here, owned a tract of land in a section of Creswell folks still called "Gusstown" after Gustanna. James's tract was large enough for a family compound on which his siblings, adult children, and 110-year-old mother, Mazy Bennett Cabarrus, all lived in 1910. James Cabarrus was a carpenter during slavery and greeted freedom with highly marketable skills. He also often signed on as a day laborer for other farmers, leaving his own crops for Gustanna and their children to manage.

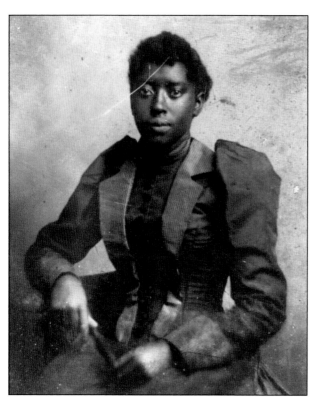

This 1890s tintype of a tightly corseted Cora Ann (Annie) Cabarrus Leigh (1878–1942), daughter of James Lemit and Gustanna Cabarrus, says much about being poised and posed for the camera. She married William (Willie) Leigh (1881–1946) in 1903 and had five children: Tellie, Edith, Jackson, Winnie, and Lillie. The family lived on the Cabarrus family land and worked the fields all their lives.

Providence "P. D." Cabarrus (1881–?), son of James Lemit and Gustanna Cabarrus, signed on with a logging company in Bells Mill, Virginia, before reaching his 20th birthday. Over time, contact with his North Carolina relatives was lost. This 1890s tintype taken while he lived with his parents is all that remains for his North Carolina kin.

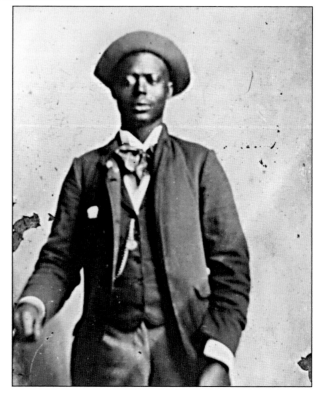

"Good Mornin, Mornin" is how Alpheus Littlejohn (1852–1916) greeted his wife, Mouring Dickerson (Dixon) Littlejohn (1869–1946), pictured here around 1890. Alpheus and Mouring married in 1875 at St. Mark A.M.E. Zion Church in Creswell. In 1888, he purchased his first 50 acres for $450 and then purchased more land in 1898 and 1908. In time, he built a spacious and inviting home for his family, which included nine children and frequent guests. On one visit, Alpheus's father, Fred, urged his son to take his sharp-tongued wife outside and teach her a lesson. Alpheus calmly responded by inviting his father to take Mouring outside himself and do whatever he felt that he could do with her. That ended that conversation.

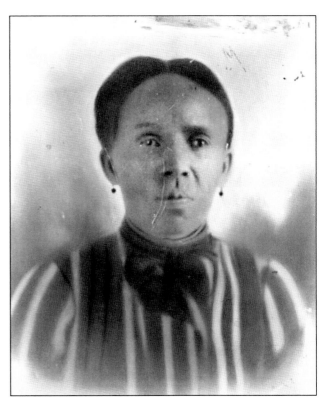

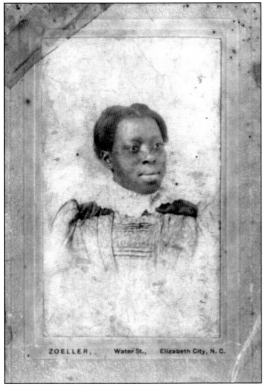

ZOELLER, Water St., Elizabeth City, N. C.

During slavery, Alpheus Littlejohn was legally denied an education. Pictured here is his daughter, Amy Littlejohn Roberts (1878–1935), wife of Malichi Roberts, graduating from Elizabeth City State Normal School (for blacks) in 1895. Her brother, Prof. Peter Wallace Littlejohn (1896–1975), became the principal of the Creswell Colored School.

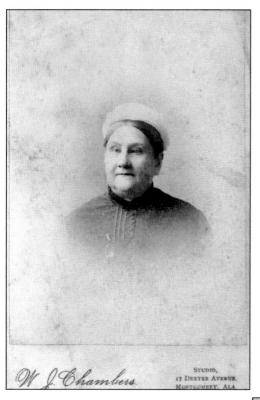

This 1890 cabinet card photograph taken at the W. J. Chambers Studio in Birmingham, Alabama, of Elizabeth Alethea Collins Warren (1824–1890) bridged the distance between family members. On the back she wrote, "For my dearest niece Gertrude M. Shepard," who was then living in Edenton, North Carolina. Both of Alethea's parents, Josiah Jr. and Ann Collins, had died by the time she was 15 years old, and she spent a few years living at Somerset Place under the guardianship of her older brother, Josiah III. She married Dr. Thomas D. Warren (1817–1878) in 1863 and had two sons, Josiah and Hugh. Following the death of her husband, Alethea moved to Faunsdale, Alabama, to live with her sister, Louisa Harrison Stickney, and died there.

Rebecca Anderson Collins Wood (1858–1921), wife of Frank Wood (1858–1926), was just as "proud as a peacock" when she posed for this 1893 cabinet card photograph of herself with her infant daughter Rebecca Bennehan Wood Drane (1892–1984). Little Rebecca's travel by train from Edenton, North Carolina, to J. H. Foster's Norfolk, Virginia, studio for this picture was just the first installment on a life of travel to wonderfully different and exciting places. She would one day travel across the country to marry at her cousin Josiah Collins V's home in Seattle, Washington, because it was halfway between Edenton and Nenana, Alaska, where her husband to be, the Reverend Frederick Blount Drane (1890–1982), was serving as an Episcopal missionary. From that point forward, wherever in the country his ministerial service took him, Rebecca went too.

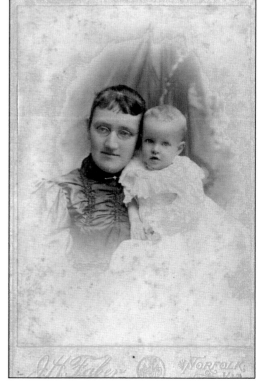

Relying on pictures to chronicle one's life and times can prove perplexing. All living descendants, including his only child, Trumilla L. Brickhouse (1914–2000), say both images on this page are of Arthur Alexander (1885–c. 1930), son of Peter and Jenny Bryant Alexander. This first image is a small photograph, mounted on a decorative two-by-three-inch card stock, was presumably taken between 1895 and 1900 when Arthur was in his teens. The second image is an enlarged 16-by-20-inch framed photograph of what could still be a young Arthur, perhaps taken sometime before 1930. A curiosity lies in the fact that both Arthurs are wearing the exact same shirt and bow tie. Arthur Alexander died at a young age in a tragic accident while working in the logging woods. Could the second image be an artist's rendition of an older Arthur made from the younger image as a family keepsake and perhaps a wish for the life that might have been?

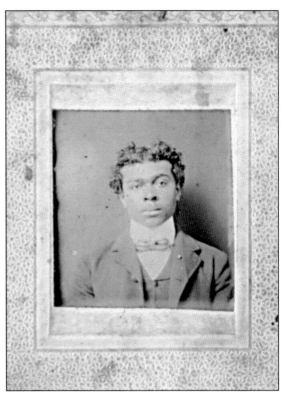

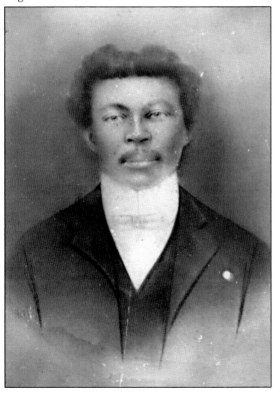

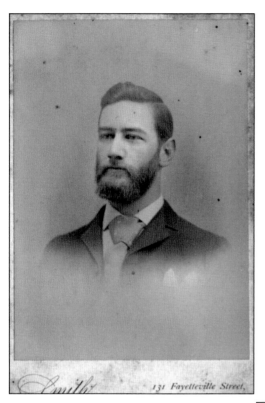

131 Fayetteville Street,

George William Kent Collins (1869–1946) was the oldest son of George Pumpelly Collins and Annie Cameron Collins. After the Civil War, his family settled first in Tunica County, Mississippi, where his father managed the business affairs of his father-in-law, Paul Cameron, a wealthy planter of Orange County, North Carolina. Later the family returned to their home state of North Carolina, settling permanently in Hillsborough. This cabinet card photograph was taken at Smith Studio in Raleigh, North Carolina, around the 1890s.

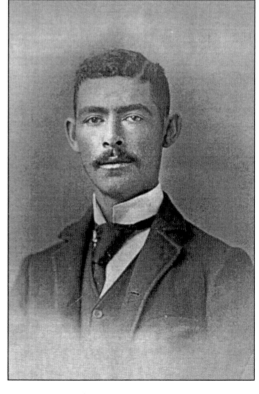

Thomas Butler Murdough (1872–1913), son of Margaret Murdough (1849–1914) and Octavious Coke, married Isadora "Dora" Sessoms-Muse and had three children before his death. According to family tradition, as his name indicates, he worked as a butler. This photograph is thought to have been taken around 1890.

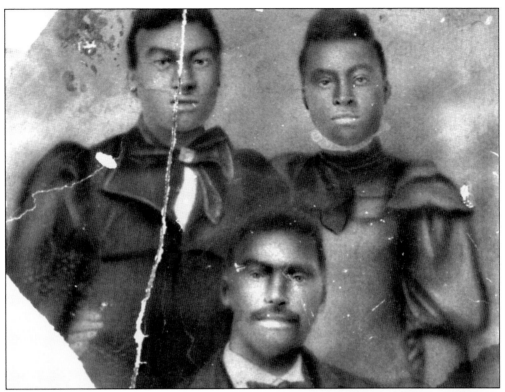

According to family members, 20th-century descendants had a composite, artist-enhanced, picture created from three separate 19th-century images. Pictured here are Merchal Reeves Davenport (1875–1927) with her father Hardison Reeves (1852–1927) and her sister Annie Matilda Reeves Baum (1874–1946). Hardison was one of 14 children born to Somerset blacksmith Diamond Reeves and his wife, Mary Littlejohn Reeves. In 1853, Hardison's father ran away from Somerset Place. He was caught several days later carrying a pistol and a complete set of "false keys" to open the plantation's locked buildings. Diamond had fashioned the keys at his blacksmith hearth.

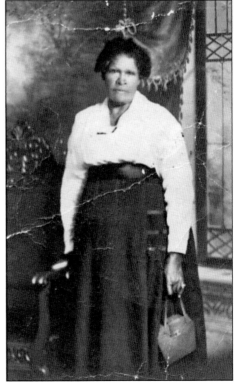

This c. 1940 picture is of Rhiney Reeves Bennett (1852–1945), wife of Arthur Bennett, another child of Diamond and Mary Reeves. Her youthful appearance belies the fact that ex-slaves were living into the mid-20th century.

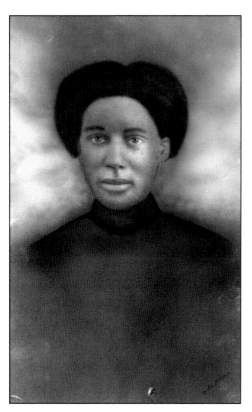

Susan Harrell Lowther (1888–1918), Edward Lowther's wife, died during the global influenza pandemic of 1918. With no effective treatment capabilities or isolation strategies, the widespread, highly contagious flu blighted many families. It is described as the worst epidemic of any kind in living memory for northeastern North Carolinians. The original image, a tintype made around 1900, became the family's only picture of Susan. In 1969, the family had the earlier tintype copied, enlarged, and colored.

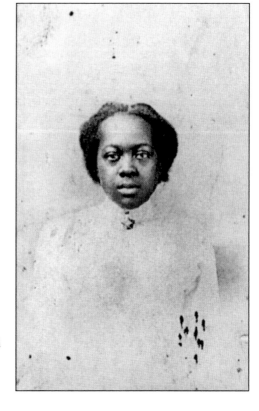

Rolande Ophelia Johnson Wood (1884–1937) met her future husband, Rev. Arthur Lorenzo Wood (1886–1962), when they both attended Edenton Normal and Industrial School. Reverend Wood was a direct descendant of Kofi and Sally, two of Somerset's native Africans. By 1910, Rolande had graduated and was a schoolteacher in Edenton, North Carolina.

Freeman and Eliza Cabarrus left Somerset Place for Edenton in 1865. They moved 10 years later to Elizabeth City, where this fetching, c. 1900 enlarged photograph of their daughter, Margaret Ann Cabarrus Morgan (1881–?) was made.

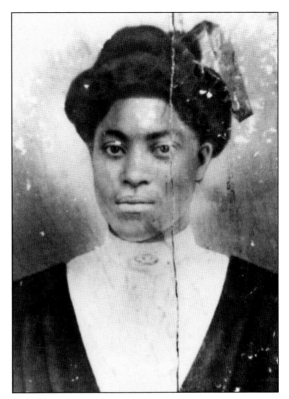

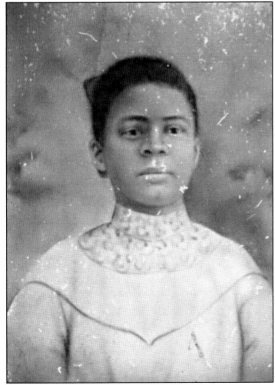

By around 1900, enlarged pictures were taken of adults and, as seen here, of youngsters, too. Minnie Brickhouse (1880–1967) appears to be pre-teen when this 16-by-20-inch photograph mounted on card stock hung in the parlor of her ex-slave parents, Robin and Matilda Brickhouse.

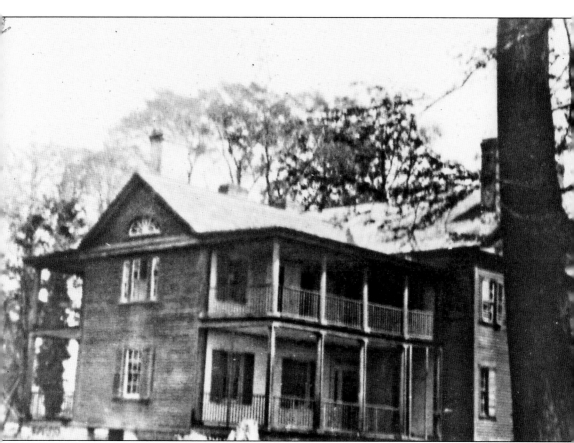

By the turn of the 20th century, Somerset Place and the Collins Family Home had fallen into disrepair. The plantation had a series of owners between 1872 (when the Collins family last owned it) and 1900; none of the postwar owners could afford to maintain the 14-room, 6,000-square-foot house in its pre–Civil War condition. This photograph was taken around 1898.

Three

POISED AND POSED
1901–1950

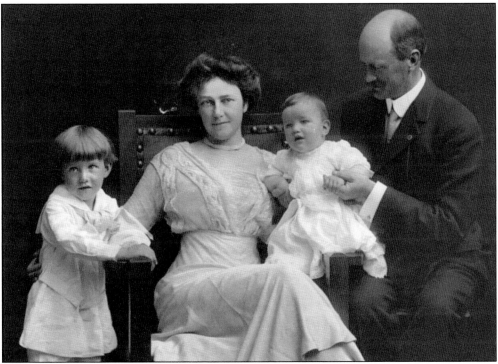

Josiah Collins VI (1908–1990), Caroline Wetherill Collins (1876–1928), Wetherill Collins (1911–1984), and Josiah Collins V (1864–1949) are pictured here from left to right. Josiah V, the oldest son of Josiah Collins IV and Sarah "Sally" Jones Collins, grew up in a Hillsborough, North Carolina, home plagued by delicate financial circumstances resulting from the aftermath of the Civil War and the concurrent end of slavery. He lived at Somerset Place for a time as a small boy and remembered taking bitter quinine to ward off malarial fevers there. Seeing no hope for a future in the postwar South, Josiah V headed west and by 1883 was living in Seattle, Washington. He worked for a time for the Spring Hill Water Company and was elected chief of Seattle's volunteer fire department. After studying law and serving for a time as a practicing attorney, he founded the International Timber Company and prospered. In 1909, he was elected to the Washington State Senate. By 1911, he and Caroline were the proud parents of two handsome little boys, Josiah VI and Wetherill, seen in this elegant family portrait.

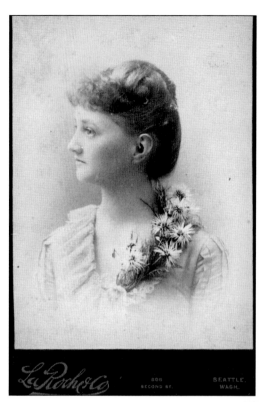

Around 1910, Rebecca Allen Collins (1868–1947), one of six children of Josiah IV and Sally Jones Collins, ventured into the studio of LaRoche and Company in Seattle, Washington, posed for this cabinet card picture, and sent copies back to North Carolina so family could see that she was well. Rebecca joined her older brother, Josiah V, in Washington and operated a teahouse there for a time. She did not marry but enjoyed helping to care for her nephews, Josiah VI and Wetherill.

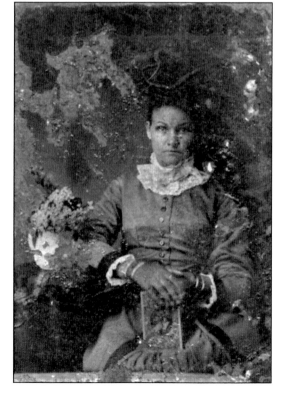

Alice Virginia Pledger Leary (1876–1950), wife of Anthony Leary, is shown here. As a young woman living in the era before dress shops, Alice designed and made her own fashionable clothing. Pictured here in a c. 1906 tintype, her creation includes various laces, numerous buttons, and lace wristbands.

Rayponsa Spruill Jenkins Dale (1892–1971) was born in the two-story house her father, Abner Spruill, built in Columbia, North Carolina. According to local tradition, "two-story people" were supposed to married other "two-story people." Rayponsa found her future husband in Setan Jenkins, whose grandfather, Rev. Ed Jenkins, earned his money as a "dragman," recovering sunken cypress trees from the Scuppernong River running through Creswell and Columbia. With his earnings, Reverend Jenkins built a fine two-story house and five little, shotgun rental homes. A real treat for Rayponsa's generation around 1910 was catching the train to Elizabeth City to have a picture made.

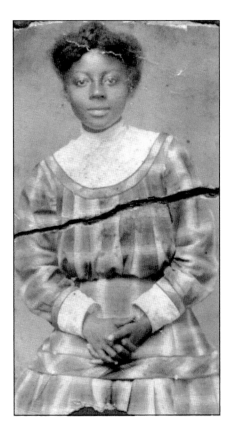

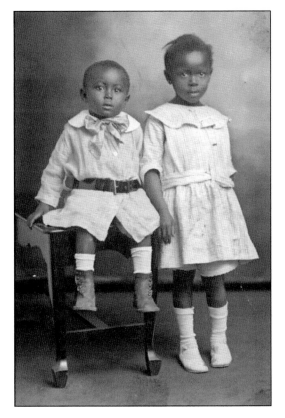

Walter (born 1894) and Ethel (born 1893) Fox are featured on the cover of *Generations of Somerset Place*. They are the absolutely adorable children of Peter and Eliza Bennett Fox. Eliza, a descendant of Washington and Jenny Harvey Bennett, left Creswell early and settled in Staten Island, New York, where she married.

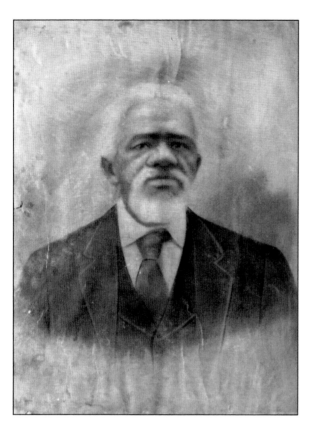

This enlarged and artistically enhanced 14-by-18-inch picture of an elderly Dempsey Fenner Jr. (1867–1934) hung on the wall of his impressive home in Creswell. Like most in Creswell, he and his wife, Amy Bryant Fenner (1869–1932), worked hard to acquire land and a home, but Dempsey and Amy seemed to have a knack making their every effort have a cash return. Amy kept a record for each family member she let have chickens, eggs, and other food items on credit. As adults, each of their eight children had to earn their keep—no slackers allowed.

Pictured here is Dempsey and Amy Bryant's Account Book. No doubt following the example they had seen used with sharecroppers, Dempsey and Amy Fenner maintained account sheets for each family member with whom they did business. These account sheets are for their adult sons: Linwood, Lora, and Leslie (Lessie). The Fenners were the first black family in Creswell to own an electric generator and have lights.

After being honorably discharged from the U.S. Army following World War I, James Ernest Fenner Sr. (1891–1929), the oldest son of Dempsey Jr. and Amy Bryant Fenner, came home to Creswell and married his childhood sweetheart, Alverta Chapman (1899–1976). They had eight children: Ernest, John, Eva, Veola and Viola (identical twins), Margaret, Hubert, and Harold. James died when his youngest child, Harold, was a year old, leaving his beloved Alverta with eight children under the age of 12 to rear.

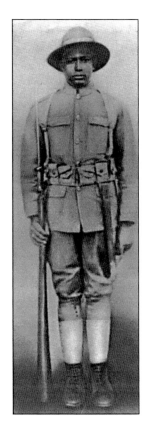

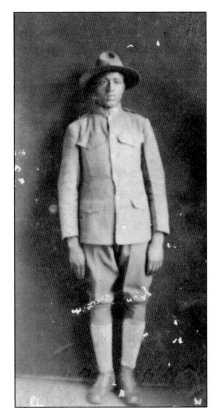

Rev. Alfred Clinton "AC" Littlejohn (1893–1963) patriotically enlisted and honorably served in World War I. He was one of seven children born to Alfred Littlejohn (1849–1927), whose family worked the fields at Somerset Place during slavery. They purchased land and worked the fields when free. But when AC put down his weapons of war, he picked up the Bible and went to preaching the fire-and-brimstone gospel in the African Methodist Episcopal Zion Church. For several decades, he served as the pastor of Walter's Temple A.M.E. Zion Church in Newport News, Virginia. The war had shown him other worlds that did not include shovels, hoes, and mules.

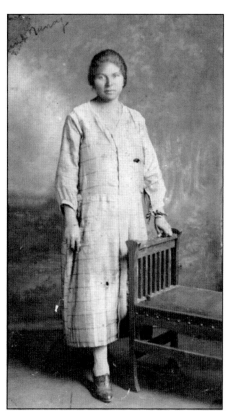

Shown in this c. 1920 real photo postcard is Nancy Barber Keyes—wife of Rev. Ivory Vyatt Keys, daughter of Elder William Henry Barber, relative to many other Disciples of Christ pastors and elders, step-mom to five, and mom to six: Wilbert, James, Ivory Jr., Llewellyn, Mary, Benjamin, and Roosevelt Keyes. Her husband "died in the pulpit just after preaching a sermon" in 1929, leaving her with six minor children to rear alone. Her oldest son, Wilbert, took on full-time work to help the family.

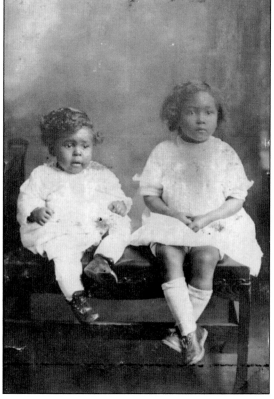

Nancy Barber Keyes lived in a small, Martin County, North Carolina, community called Free Union. In distance, Nancy in Free Union was no more than 70 miles from her big sister, Mary Barber Pailen, in Creswell, but in real time, it was an overnight trip. In 1914, when she sent Mary this photo postcard showing off her baby boy, Wilbert Davis Keyes (1913–1989) and his only sister, Mary Jane Keyes, she relied on pictures to bridge distance and time. The Reverend Wilbert D. Keyes became a Disciples of Christ minister.

Moses Alexander (1896–1976) was one of five children born to Jenny and Pete Alexander. He left Creswell in 1923 and settled in Philadelphia. There he worked for Atlantic Refining Company for 28 years. Before leaving home around 1916, he had this smart-looking tintype made for family in Creswell to remember him by. Later he moved to Williamston, New Jersey, where he died. In death, he returned to Creswell and was buried near other family members at St. John Missionary Baptist Church.

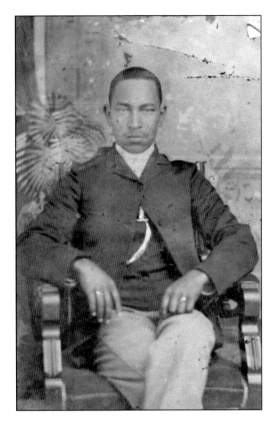

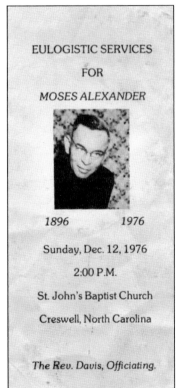

EULOGISTIC SERVICES

FOR

MOSES ALEXANDER

1896 *1976*

Sunday, Dec. 12, 1976

2:00 P.M.

St. John's Baptist Church

Creswell, North Carolina

The Rev. Davis, Officiating.

Shown here is Moses Alexander's 1976 funeral program. By the 1950s, it became fashionable among African American families to include a photograph of the dearly departed on their funeral program. Many African American families have a funeral program collector and a designated heir who would someday inherit the family's collection. They are a valuable source of documenting family history. After looking at Moses's image on his funeral program, one can almost hear the old folks who know him in his younger days say, "He sure kept his favor didn't he?"

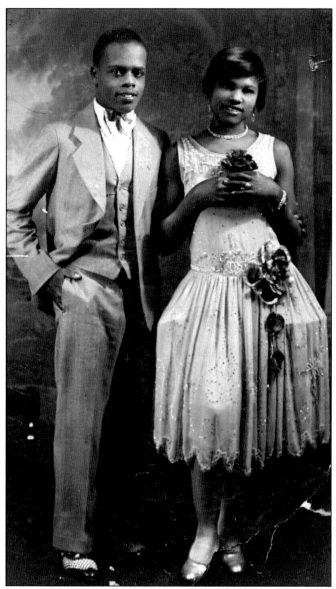

A dress very much like this one worn by Maybell Channel Shannon Young (1905–1994) appears in the 1923 New York wedding of Mae Walker Perry, millionaire granddaughter of Madam C. J. Walker. For all who knew her, seeing Miss Maybell in this upscale frock seemed perfectly normal. She was one of 11 children born to James and Sarah Davenport Channel. When she completed high school (11th grade back then), she headed for Mount Vernon, New York. By the 1890s, the African American community in Mount Vernon began to slowly swell with Southern migrants. There was no black middle class at that time. Most blacks found work as domestics, porters, waitresses, and chambermaids. The attraction was higher wages, no sunup-to-sundown fieldwork, and reduced racial and social tensions. Maybell Young found work as a domestic. She later married Charles Shannon and had three children: Minnie, Charles, and Herbert. Not long after her arrival in New York, Miss Maybell dressed in her finest New York evening frock, went to G.G.G. Photo Studio at 109 West 135th Street, had this photo postcard taken, and sent it to her girlhood friend, Ruby Mable Pailen, in Creswell.

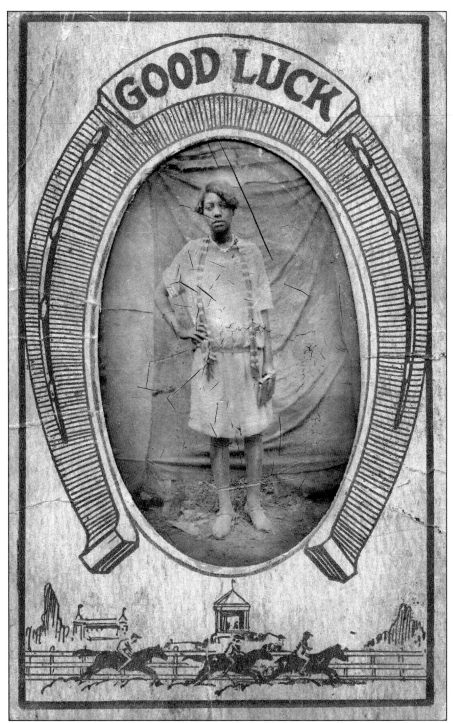

According to local family historians, this unidentified member of the Fenner-Bryant clan is dressed in her "Supreme Lodge K of K. S., Good Hope Chapter" uniform during the 1920s. The dues rose from 75¢ a month in 1922 to 85¢ in 1925. She is posed outdoors in front of what appears to be a photographer's inexpensively hung canvas backdrop.

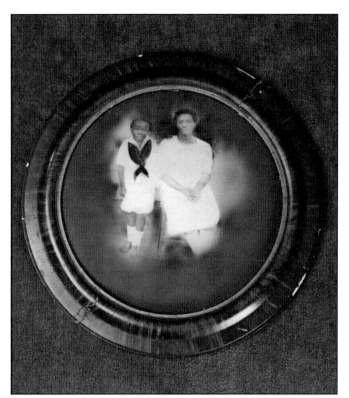

Folks say Minnie Brickhouse McCleese (1882–1967) was one of 20-some children born to Robin and Matilda Brickhouse—pronounced "Brickus." She spent most of her years working the fields in and around Creswell, scraping to care for her daughters, Sadie B. Lynch (1901–1968) and Trumilla Lugene Brickhouse (born 1910). Miss Minnie and Sadie posed for this enlarged photograph around 1929. The image is displayed in a hand wood-grained "bubble" or convex glass frame, a type seen in many homes during the first half of the 20th century.

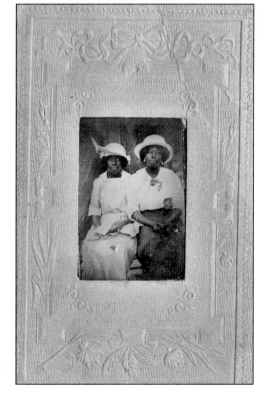

It appears that a wise itinerant tintypist set up shop in Creswell on Sunday, right after church, and captured Eva Hassell Fenner, wife of Stewart William Fenner Sr. (1872–1945), and an unidentified friend in their Sunday best. Hats had to be worn to regular "preaching" services, weddings, and funerals. On Sundays, folks were already dressed up and more likely to have their pictures taken.

The home that Ernestine Spruill (1885–?), daughter of Major and Caroline Spruill, grew up in was described as "up the railroad tracks in a two-room hut with an outside kitchen." In this 1929 real photo postcard taken for her only child, Lina Doris Spruill Beane, mom donned the fanciest, bejeweled frock she could find and preserved a moment in time when she looked like a million bucks. On the back of the picture, her daughter lovingly wrote, "You are my first Sweetheart, my mother Ernestine."

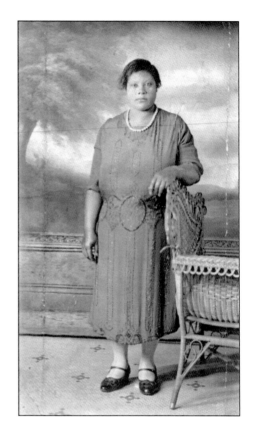

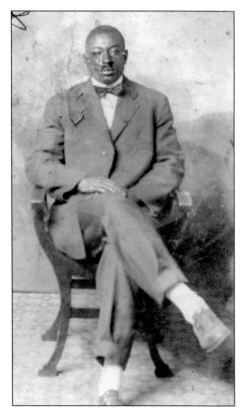

With the popularity and inexpensive cost of real photo postcards, studios specializing in this medium soon opened. By 1910, Setan Jenkins (1893–1965) could board the Norfolk Southern Railroad train in Columbia, North Carolina, and ride the rails all the way to Norfolk, Virginia. There Church Street was the hub of activities including barbershops, beauty salons, churches, and merchandising outlets catering to African Americans. Around 1920, Setan Jenkins, son of Louise Anna Jenkins, visited the Postal Studio at 516 North Church Street in Norfolk, Virginia, and had this picture postcard made. As a method of advertising, the name of the business was stamped on the back of the picture in a way that still permitted the postcard to be mailed.

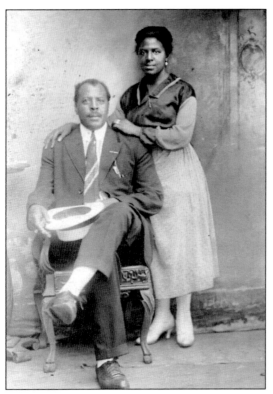

According to the rather provocative family folklore, Ransom Bennett Jr. (1874–1930), son of Ransom and Catherine Bennett, got into a fight with a white man in Creswell, beat him half to death, and had to be taken out of town in the "dead of night." He wound up fighting in the Spanish-American War, rode with Teddy Roosevelt's Rough Riders, later settled in New Jersey, opened a tool-and-dye plant, married four times, and lived the good life. He is pictured here with his daughter Catherine around 1920. She reputedly owned a tavern in Atlantic City, New Jersey.

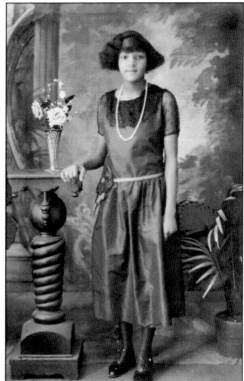

This stylishly dressed young lady's 1920s picture was in the collection of Ransom Bennett Jr. and may be one of his daughters or grandchildren.

Trumilla Lugenia Brickhouse (1914–2000) was the first member of her family to attend college. She graduated from Elizabeth City State Normal School in 1929 and taught school for 45 years. She was part of a generation of schoolteachers who insisted on professional decorum at all times for her colleagues and instilled in her students their responsibility to be good role models for their race. Long after a colleague had died, Miss Brickhouse still severely criticized her for cooking a pot of beans for her family's supper on the classroom's potbelly heating stove. Miss Brickhouse generously devoted her retirement years and financial resources to St. John Missionary Baptist Church in Creswell.

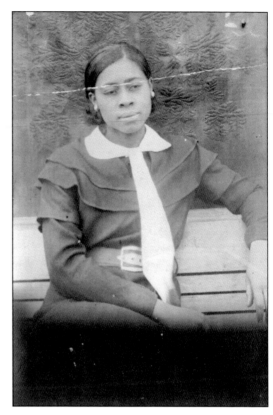

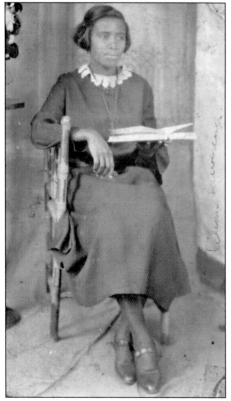

Isoline Davenport Lawrence, wife of John Lawrence, was one of 12 children born to Africa Davenport and Henrietta Hill Davenport Paige—known to all in Creswell as the "superior-excellent" midwife "Mammy Ret." Isoline's father, Africa, worked the fields by day and spent nearly every weekend going from house to house (black and white) and playing the fiddle for parties. Learning was Isoline's joy in life, and she captured just that in her 1929 picture.

By the 1930s, schools began to take annual identification photographs of students for their school records. Pictured here is Lionel Hope (born 1925), husband of Somerset descendant Emma Littlejohn Hope, in his 1931 first-grade school picture.

The 1930s also saw the emergence of carnival photographs in Creswell. They were instantaneous and sometimes captured expressions that were open to interpretation. In this picture of John L. Pailen (1917–1988), a friend wrote, "getting married soon." Maybe this explains his perhaps untypical facial expression. He did marry Gladys L. Pailen (1918–1985) in 1939 and remained happily married until his death.

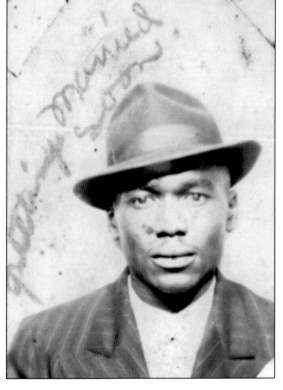

Rev. Wade Hampton Owens (1888–1959) was the son of Jessie and Lizzie Spruill Owens, husband to Louvenia Rowsom, father of Victor and Wallace, and a member of the first generation in his family born free. After graduating from high school, he attained a certificate in theology from Shaw College (now Shaw University) in Raleigh, North Carolina, and came home to farm and sell life insurance. He eventually opened a grocery store and the first dry-cleaning establishment in the town of Columbia, North Carolina. This most dignified pose with hands resting on his Bible was taken during the 1930s.

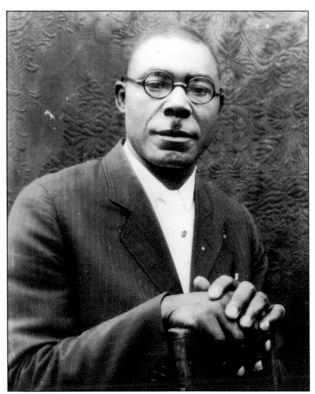

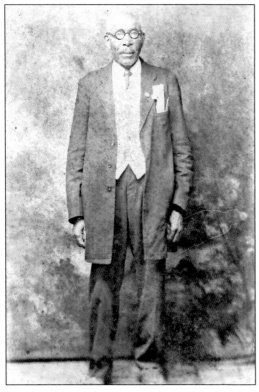

This photograph, taken during the 1930s, is of Rev. Isaac Leigh (1858–?), eldest son of Hiram and Mary Ann Leigh. He married Adoline Harvey in 1877, then Phoebe Blount in 1885, and had six children from both unions. His ministry took him from Creswell first to Elizabeth City, North Carolina, and then on to Norfolk, Virginia, where he died. Interestingly, his enslaved mother, Mary Ann, was purchased from William Hall of Norfolk in 1854, when she was 17 years old.

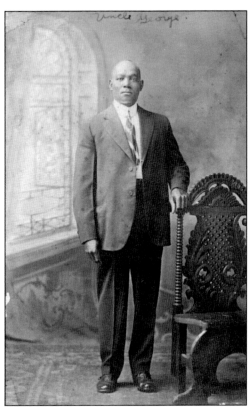

George Pailen (born 1875) saw no possibility of earning the future he wanted in Creswell, and by 1900, he had moved to Washington, D.C. There he opened a barbershop and did well. Over time, the connection between George's descendants and his Creswell kin has been lost. This striking photograph that George sent to his now long-deceased brother, Llewellyn Pailen, is all that remains.

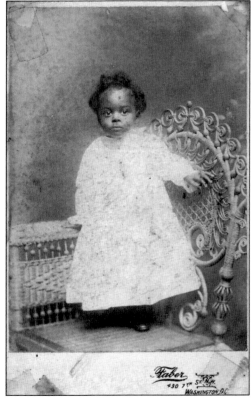

Relatives feel this unidentified, c. 1900 cabinet card photograph made at Faber Studio in Washington, D.C., is a child of George Pailen.

The ancestors of Johnson Walter Littlejohn (1888–1946) were brought to Somerset Place in 1829 from the Littlejohn Plantation near Edenton, North Carolina. After emancipation, Johnson's father, Alfred, left Somerset Place and settled in Edenton, where Johnson was born. He married Elizabeth Granby (1890–1950) and had 13 children to help work the more than 100 acres he acquired. The family became founding members of Canaan Temple A.M.E. Zion Church.

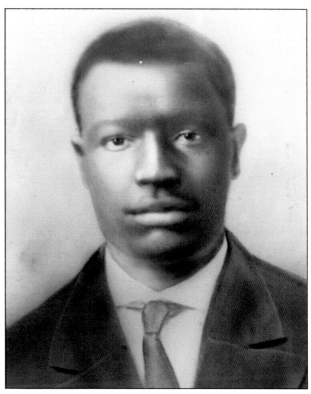

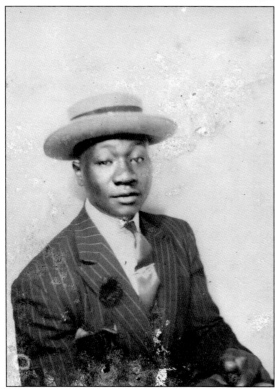

This is a photograph of Johnson's son, Melvin Littlejohn (born 1927). When dad and mom died, Melvin left the family farm in North Carolina and headed for Norfolk, Virginia. Seen here is his "executive" look.

Elder Haywood Baum (1871–1957) married Annie Matilda Reeves Baum (1874–1946). He was a farmer and a Disciples of Christ minister. Annie was a schoolteacher. The couple had 10 children. Like her mother, their still-living daughter, Moriah Baum Wills (born in 1908), also became a schoolteacher.

Born a slave in 1853, an aging Jordan Spruill is pictured here on the front porch of his son Lonnie Spruill's home in Creswell, dressed in his "Sunday go to meeting" finest. He married free-born Sarah Freeman (born 1869) in 1881, and together they had six children who, like their mother, never knew bondage.

William Lieutenant Pailen (1901–1990), son of John and Edith Pailen, left but one image for his wife, Mercedes. This image was taken in the small portable studio when the carnival came to town.

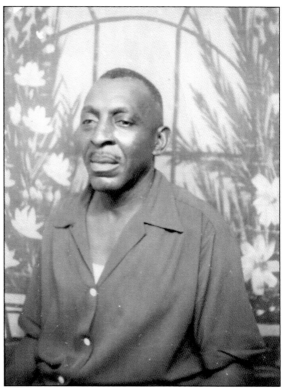

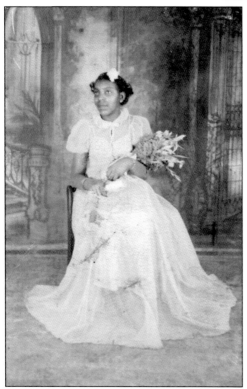

William L. Pailen's daughter, Audrey Pailen, lived in the North. When she became a debutante, she sent her dad a picture postcard on which she wrote, "To the Dearest Daddy in the World."

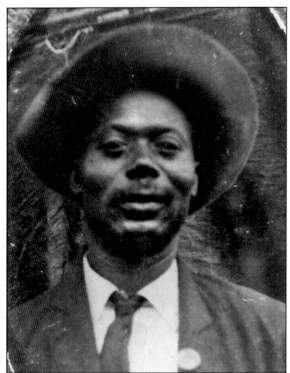

James Lemit Cabarrus (1870–1954), pictured in this c. 1930 photograph, was never content just getting by. He farmed his 28 acres and ran a little grocery store, giving his wife, Betty, and their six children a pretty good life. When the crops came in each year, everyone had money and settled accounts at the store. That's when the Cabarrus family got new things. His daughter said when he replaced the mule and cart with a brand new horse and buggy to go to church in, they thought they were really "on the top shelf."

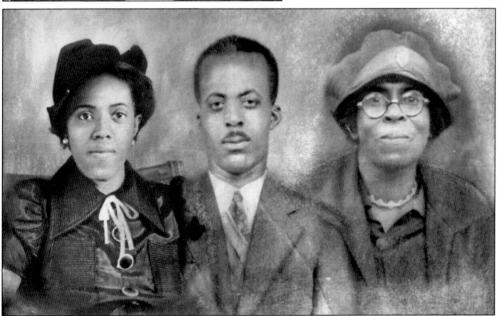

Pictured from left to right in this composite picture are Odessa (1819–1994), her brother John Henry (1907–1988), and their mother, Betty Horton Cabarrus (1885–1946), the wife and children of James Lemit Cabarrus Jr. John Henry left Creswell and found work as a long-distance trucker. Odessa stayed and worked first in the fields for 10¢ an hour, then as a domestic for $2.25 a week. She finally signed on for a 40-year stint as a custodian at the Creswell High School. She used to say, "I'm making some real money for now and some real retirement for later."

Stella Fenner Anthony (1915–1967), wife of Willie Percy Anthony Sr. (1907–1981), left Creswell for Mount Vernon, New York, by 1930. There she secured a job as a housekeeper, and her husband became the city's first Negro bus driver. Their only child, Willie Jr., born in Mount Vernon in 1933, said his mother loved to dress up and always looked good. These head-to-toe picture postcards show Stella's fashionable style. She went to the same studio posing with the "flapper look" of the late 1920s to the 1930s and again around 1941. Both postcards were mailed back home to family members in Creswell.

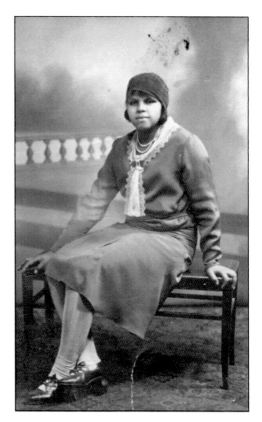

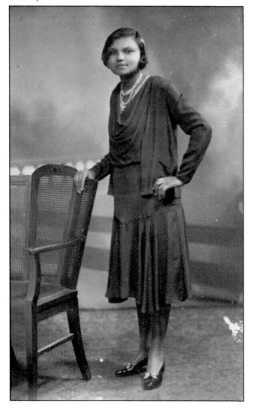

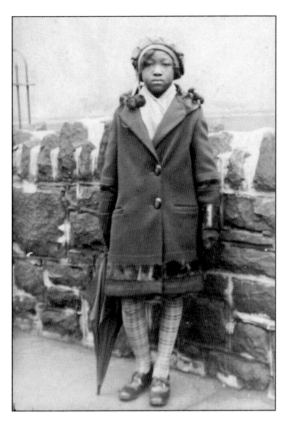

This picture postcard of Geraldine Davenport, granddaughter of Clinton and Cora Davenport, carries the following message: "Mother Cora, This is the baby promote picture. She is standing in the meat schoolyard at recess just like she goes to school. It was a raining day to."

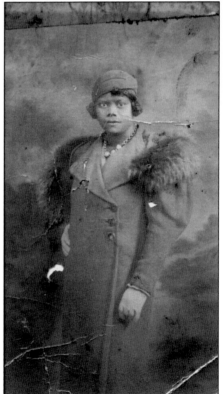

Posed just so for the camera, the card is from Frances Miller at 2 Bose Street, First Floor, Newark, New Jersey. She is an unidentified family member or friend of the Jordan Spruill family.

Ernest Littlejohn (1905–1989), son of Medicus and Nettie Jones Littlejohn, sent this picture and message "to my Darling Grandmother," Eliza Jones. Respect dictated that everyone in Columbia call her "Miss Liza" or "Momma Liza" Jones. Ernest was honorably discharged following World War II in 1945 and settled in New York.

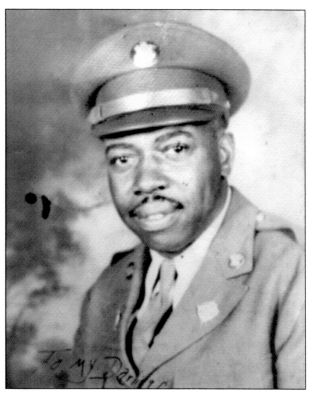

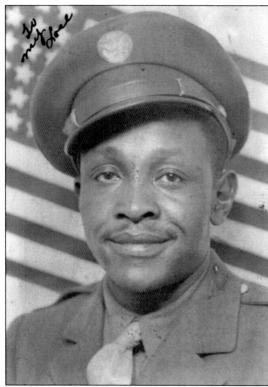

Lessie Chapman's World War II message "To my love" was sent to Clara Jenkins Preston, who held on to it for 60 years until it was collected for this publication.

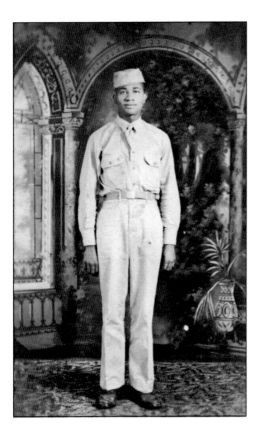

James Edward Littlejohn (1914–1973) was the son of Johnson Walter and Elizabeth Granby Littlejohn.

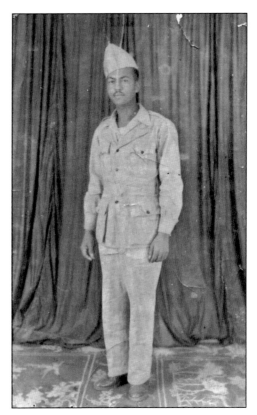

Pictured here is Cpl. Roy E. Owens in his U.S. Army combat fatigues.

By 1920, Johnson Bennett (1872–1944), son of Ransom Sr. and Catherine Bennett, had moved from Creswell to Virginia, where he met and married Beverly L. Butler (1880–1976). He and his family of 10 children abandoned the South and settled in Brooklyn, New York, sometime before 1926. This late-1930s, artist-enhanced color photograph includes a halo-effect surrounding his head.

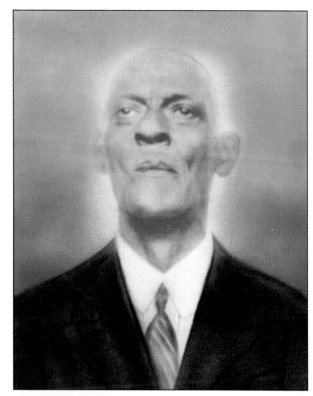

By the 1970s, chain photographic studios, such as Olan Mills, set up shop at church functions, schools, and shopping centers to corner the portrait market in small towns like Creswell. This picture is of Andrew Simpson Baum (1913–2000), a virtual walking encyclopedia for family and community history. His great-grandparents, Joshua and Annette Baum, chose to remain as domestics at Somerset Place until their deaths in 1913 and 1923, respectively. During slavery, Joshua was a coachman and Annette a maid in the "big house."

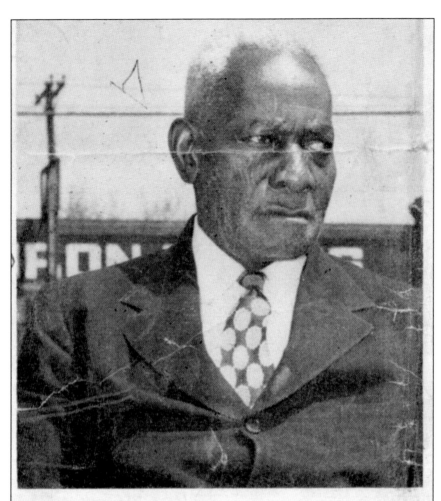

William Henry McPhailen, 112, of Suffolk, Va., believes "obedience to God" is important for longevity. McPhailen remembers being sold as slave for $750 when 13 years old and bought back by master for $1000 four years later.

Everyone, living and dead, swears this man is William Henry Pailen (1875–1961), son of Jupiter and Lucreecy Pailen, big brother of Llewellyn Pailen, husband of Janie Outlaw (who died early), and father to Lela Pailen Austin. He attended Elizabeth City Normal School, became a Methodist minister, and was eventually assigned to a church in Suffolk, Virginia. The first time something about his life seemed amiss was in 1940, when a Suffolk newspaper article reached Creswell relatives announcing the marriage of 102-year-old Elder William Henry McPhailen, who claimed to have been born in 1838 in Creswell. Ten years later, in 1950, a photographer for Ebony snapped this picture of a 112-year-old ex-slave named William Henry McPhailen who even remembered being sold twice. But the records show 1875 as his birth year and that he was never a slave. Could the allure of the camera have prompted the re-invented life? Or as the old folks use to say, "Taint everybody you can confidence."

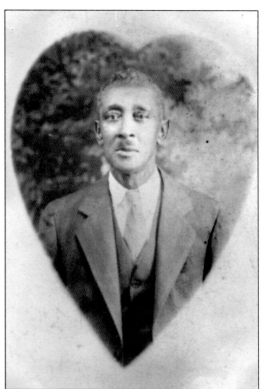

Elijah Honeyblew (right, 1861–1947) was a fifth-generation descendant of Guinea Jack and Fanny Collins, two native Africans brought to Somerset Place in 1786. Judith Littlejohn (below, 1866–1922), daughter of Peter and Elsie Littlejohn, was their first child born free. Elijah and Judith married February 22, 1882, and became the parents of 10: William, Mary, Joyce, Estelle, Herbert, Marshall, Dermy, Fred, Gladys, and Ruth. After Judith died, Elijah married Sally Freeman Spruill and moved to New Jersey where he died.

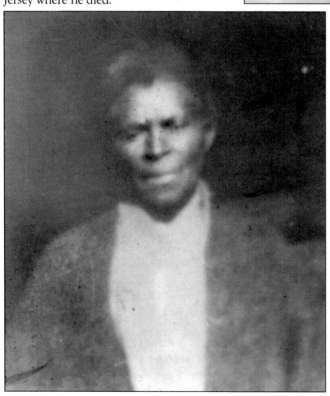

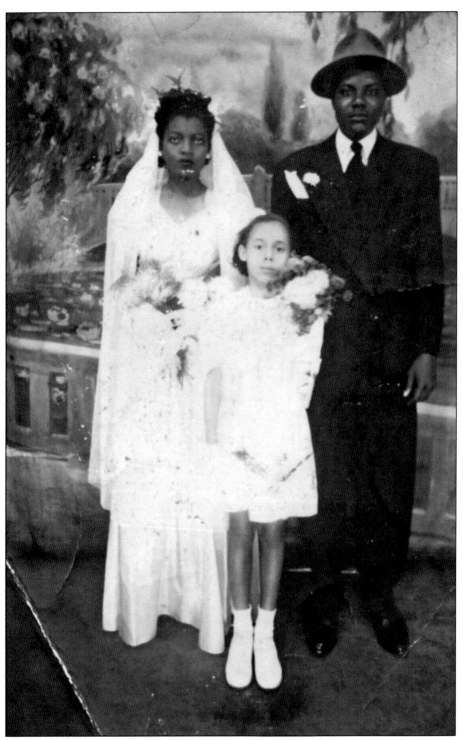

This is a studio photograph of Marie Bennett (1927–2001), daughter of Levi and Bessie Spruill Bennett, and her husband, James Allen Diggins (1924–1987), son of Preston and Martha Diggins. They married in 1945 in Norfolk, Virginia.

Four

POISED AND POSED
Since 1951

Restoring Somerset Place and turning the former plantation into a North Carolina historic site began in earnest during the 1950s. Under the auspices of the North Carolina Department of Conservation and Development, historian William S. Tarlton supervised repairs to all extant structures and restored the grounds, as near as possible, to their antebellum appearance. Pictured here is an archaeologist unearthing long-buried brick sidewalks near the kitchen/laundry building.

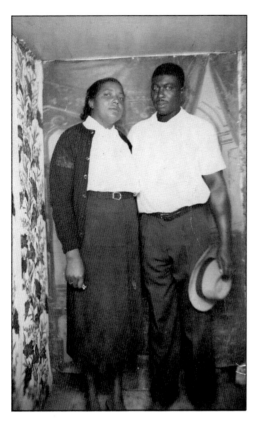

The traveling carnival spent a week each summer in Creswell. With it came rides, clowns, hot dogs and popcorn, sideshows, and the much-awaited traveling photographic studio. It was not nearly as fancy as the permanent studios in buildings and just wide enough to hold a couple of adults; still the $1 charge and 20-minute waiting time for finished photographs made this an attractive venue for family photographs. Families could take enough pictures to fill their albums and to send to far away relatives. This 1952 photograph is of Ruth Mable Pailen Owens Spruill (1913–1971) and husband, Fred Douglas Spruill (1919–1985).

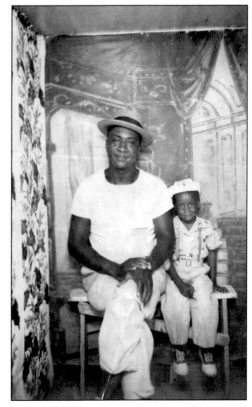

A pleased and excited little boy, seven-year-old Thurston Honeyblue Jr., poses with his father, Thurston Honeyblue Sr. (1916–1984) in this 1952 carnival photograph.

Carnival pictures made it possible for Haywood Leigh Sr. (1900–1977) to create the illusion that he was in a "New York Photo" without leaving Creswell.

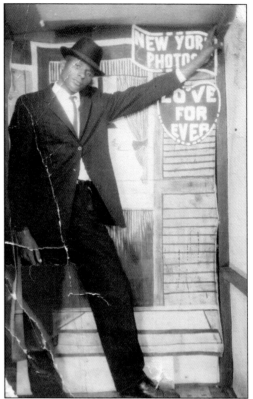

Lonnie Spruill's carnival studio backdrop included a fine home and spanking-new, two-dimensional car. At the time, he and his wife, Lillie Mae Myers, lived in a two-story, five-bedroom home called the Spruill House, which is still standing.

HOMEGOING SERVICE
LELIA VIRGINIA CALDWELL

June 4, 1897 July 5, 1998

Thursday, July 9, 1998
3:00 P.M.
Saint John Missionary Baptist Church
Creswell, North Carolina
Rev. Hearlen M. Trotman, Pastor

Rev. James H. Rodgers, Officiating
Chapel Hill Baptist Church
Chapel Hill, North Carolina

Lelia Virginia Hill (1897–1998), daughter of George T. and Carrie Alexander Hill, lived to be 101 years old and had a remarkable life. Her formative years were spent working on the family farm and attending Creswell's one-room colored school. In 1915, she moved to Suffolk, Virginia, to complete her studies and married John Caldwell there. The couple soon settled in Washington, D.C. A bright and ambitious woman, Lelia became a self-employed seamstress whose clientele included the wives of members of the Eisenhower administration. She was crowned Miss Ebony Magazine in 1973; traveled to Hawaii, Mexico, Japan, Hong Kong, Bangkok, England, France, Israel, Spain, Dakar, Nigeria, Liberia, and the Ivory Coast; and was presented with a birthday cake from the bakery at the White House to go along with her greeting from Pres. Bill Clinton on her 100th birthday. Her desire was to be laid to rest in Creswell's St. John Baptist Church cemetery. This oil-on-canvas picture adorned her 8-by-11-inch funeral program in 1998.

Della Roberts (1881–?) is pictured here. She was the daughter of Jackson and Fanny Honeyblue Roberts and a descendant of Guinea Jack and Fanny Collins—two of Somerset's native Africans. Fieldwork and hard work were all that Della knew. By 1920, she was a single mother with six children to care for. Later, two of her sons would be murdered. Still she was a woman of faith who maintained her membership in St. Mark A.M.E. Zion Church, where her parents had taken her as a child. This slightly off-centered photograph is all that the generations born after her death know of her.

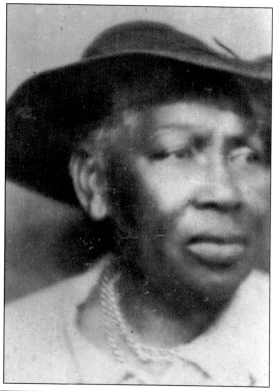

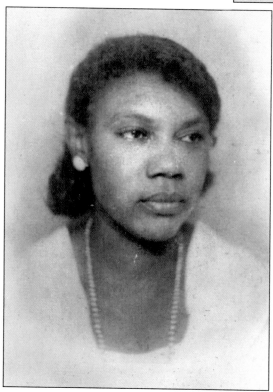

Hattie Roberts Hines (1901–?), Della Roberts's oldest child, lived with her mother all of Della's life and had her mother's help in rearing her only son, Edward Roberts (1918–1974). By the time Ed was born, the Robertses were kin to the Collins, Drews, Honeyblues, Littlejohns, and every other Creswell name. So Ed headed up the road a little to Blood Street in Pea Ridge to court Miss Ethel May Moore. The Moores had Elizabeth City blood in them. Fortunately for Somerset Place State Historic Site, Miss Ethel learned to cook by helping her mother prepare meals over the open flame of a kitchen fireplace, a skill she later passed on to the staff at Somerset Place.

Born in 1924 and pictured here in the 1930s, Viola Fenner (Mrs. Sidney Midgett) and Veola Fenner (Mrs. Alaric Ancile Hill II) are the identical twin daughters of James Ernest (1891–1929) and Alverta Chapman (1899–1976) Fenner. Viola (left) became a restaurateur, and Veola (right) opened a day care center within a few minutes' drive of the land they were born on. Veola is the proud mother of Dorothy, Larry, and Alaric III. In 1983, Veola saw a need for her family to have reunions and organized the first of what are now annual Fenner family reunions. In recent years, the reunions have been held at Somerset Place.

Five

SNAPSHOTS
1890–1950

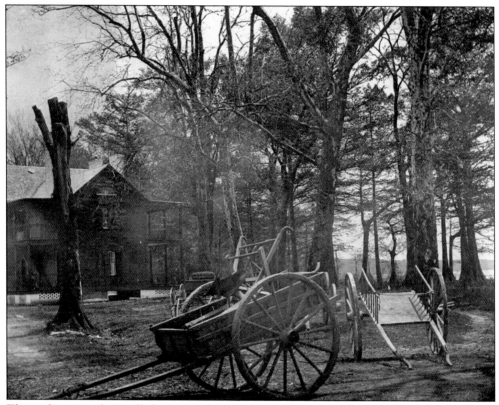

The earliest snapshots tell the story of the decline of Somerset Place. By 1898, Harvey Terry and his new Scottish bride, Alice Leighton, owned Somerset Place. Terry hired Alice's brother James as overseer, and the entire Leighton family emigrated from Scotland to their new home. Jane Leighton Davis Sexton said, "The Big House had been sadly neglected and run down. We painted and made repairs." This 1900 picture shows the once manicured yard near the Collins Family Home unkempt.

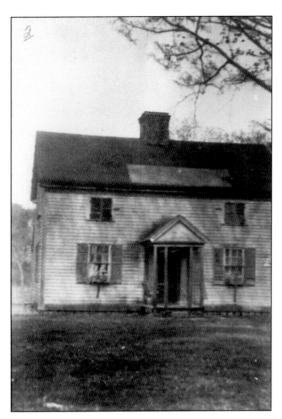

The once pristine Colony, built in 1841 and used as a residential school for the Collins boys, sported braced flower boxes in the windows in 1900. Before the Civil War, the Collins boys shared the building with resident ministers and tutors. Mary Collins and her son Arthur lived in the building from 1865 until her death in 1872.

Early-20th-century residents and visitors to Somerset Place still traveled the carriage trails beside the five-to-six-mile long irrigation, drainage, and transportation canals dug by enslaved laborers a century earlier.

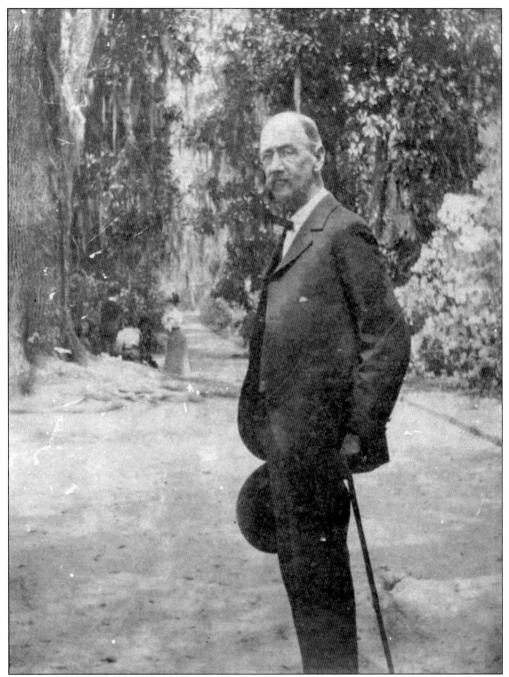

The convenience of personal cameras made preserving special vacations possible. Around 1900, George Pumpelly Collins (1835–1903) had this snapshot made while vacationing with his family at Magnolia Gardens in Charleston, South Carolina. George, son of Josiah III and Mary Riggs Collins, was born at Somerset Place but left his childhood home soon after his 1860 marriage to Annie Cameron Collins (1842–1915) to work for her father, Paul Cameron. The Collinses had eight children. Two of their daughters, Henrietta (1870–1955) and Mary Arthur (1872–1952), can be seen in the background of this photograph.

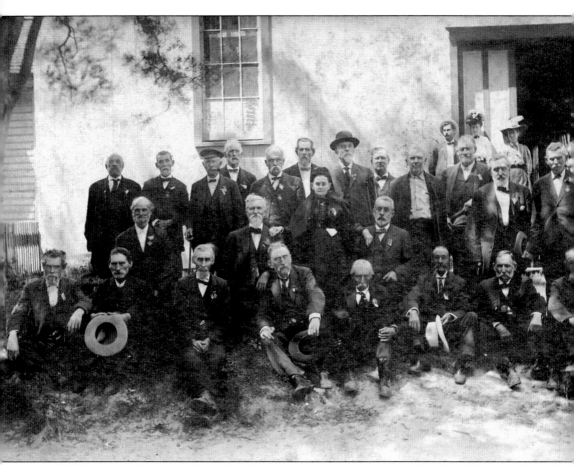

All three sons of Josiah Collins III served the Confederacy during the Civil War. After the war, the youngest son, Arthur Collins (1842–1913), returned to Somerset Place along with his widowed mother, Mary. He cared for her until she died in 1872. Arthur was able to hold onto one of the plantation's farms, called Weston, until 1886, when it had to be sold to pay debts. He was the last member of his direct line to live on the plantation's grounds. In 1908, some 43 years after the Civil War ended, Arthur attended a Confederate Reunion and Dinner along with other aging veterans. This snapshot commemorates the event. On the back row, the eighth person from the left is Arthur's first cousin, William B. Shepard. Arthur is the tenth person from the left in the same row.

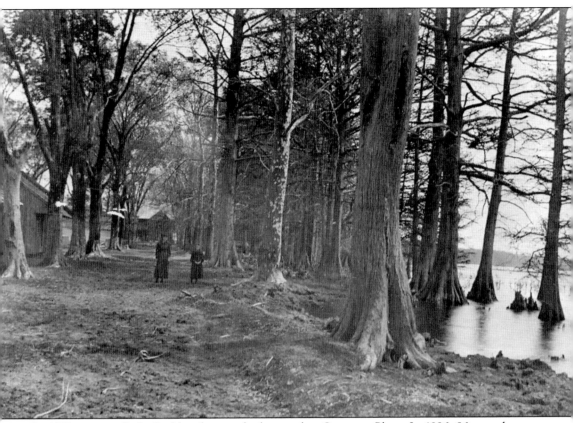

In 1910, investor R. L. Burkhead secured a loan to buy Somerset Place. In 1996, 86 years later, his 95-year-old daughter, Martha Burkhead McCorkle, shared memories of her brief stay on the plantation. Her family lived in the Collins Family Home, where land snakes crawled around the porch banister and water snakes lurked in nearby Lake Phelps. She remembered canoe rides with her father in the six-foot-wide ditches that drained the immense fields at Somerset Place and having doves eat rice right out of her hands. She and her sister called the plantation's two remaining small slave houses their playhouses. This photograph, taken around 1910, shows the c. 1829 slave houses. Two unidentified women are strolling down the lane where 26 small slave houses once stood. By 1914, the plantation had been sold to R. S. Neal of Beaufort County, North Carolina, and the Burkhead family moved on.

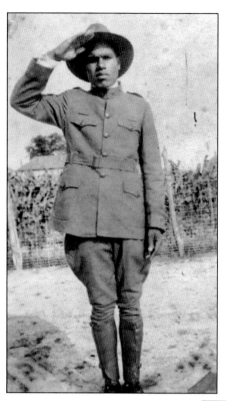

Studio photographs of soldiers are often taken at attention with hands down at the soldier's side. Rev. John T. Hill (1895–1980) had his World War I picture snapped for his family around 1914 in Columbia, North Carolina, with a full regulation salute. He married in 1920, accepted a spot on the pulpit of Zion Grove Disciples of Christ Church, and took up his prewar profession. Six days a week, Reverend Hill supported his wife, Daisy Sawyer (1903–1976), and their 10 children working as a professional ditch digger. At least once a year, all farmers had to clear the drainage ditches in their fields of accumulations of dirt and debris. John Hill was an expert at "ditching" and clearing large tree stumps and roots from fields.

This c. 1920 photograph of Rhonie Davis Leigh (1872–1937), wife of Andrew Leigh (1862–1936), was snapped on Somerset Place land where the family worked as sharecroppers. Her grandfather, Luke Davis, was a butler for Josiah Collins III and among only a few ex-slaves who remained at Somerset Place after emancipation. The house servant version of "This Little Piggy" came down in her family's oral tradition: "This little Piggy says, 'wee, wee.' This little Piggy says, 'I want some corn.' This little piggy says, 'where you gonna get it from.' And this one says, 'from the masta's barn.' And this one says, 'I'm goin' tell it, I'm goin' tell it, I'm goin' tell it!' "

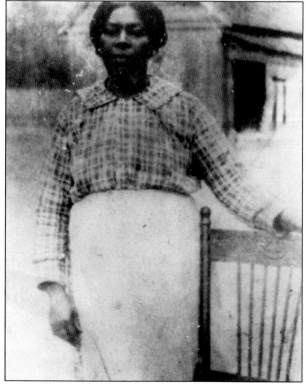

William Honeyblue (1887–?) was a logger. His wife, Minnie Riddick Honeyblue (1890–?), taught school. They pooled resources to provide a comfortable lifestyle for their five children. This spontaneously taken photograph is of William bedecked in his work clothes and positioned against his house in Creswell.

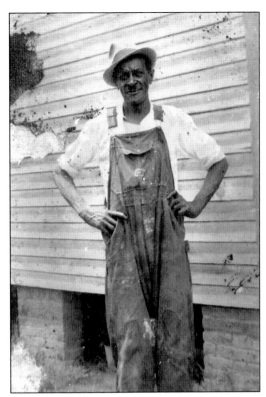

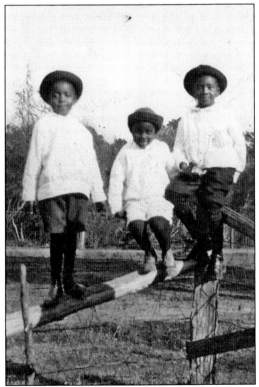

In 1922, proud parents William and Minnie Riddick Honeyblue dressed their rough-and-tumble boys, William "Bay Bro" (born 1917), Richard (born 1918), and Thurston Honeyblue (1916–1984), to look like models and snapped away. By 1925, two daughters, Anna Rose (born 1922) and Doris (born 1925), made the family unit complete.

The Tar River Farm Development Company of Edgecombe County, North Carolina, acquired Somerset Place in 1922, and the George Washington and Victoria Patrick Smith family moved in. The Smiths were to manage the "resort" Somerset Place was to become. There was a dance hall on pilings situated over Lake Phelps, and the "big house" had rooms for rent to hunters and fishermen. This picture, taken in 1923, shows five of the Smith girls. They are, from left to right, Wilma (born 1920), Georgana (born 1925), Doris (born 1922), Lona (born 1927), and Hazel (born 1916). The buildings in the background include the south end of the original Plantation Hospital and the wood house, in which slaves stored wood all year for use in the 16 fireplaces in the Collins Family Home and in other nearby buildings. Behind the wood house is an original plantation storage building. The building closest to the girls is the Colony.

This photograph captures Samuel Smith, the oldest son of George and Victoria Smith, his wife, Myra Hassell Smith, and their Model T Ford parked in front of the Colony, where the Smith family lived and where George Smith died in 1930. In the background is the original plantation building where meat was salted before it could be smoked; the original Dairy, then used as a Delco (electrical generator) building; and the plantation kitchen, which had been converted into a general store where hunters could shop.

When Somerset Place was an active plantation, a gristmill (for grinding wheat and corn) stood almost directly in front of the Collins Family Home. Cornmeal and flour were issued weekly to enslaved families. By 1923, the millstones had become playthings for Lona and Buna Smith. Lona remembers the family was poor, but when their big sister Mary came down from Norfolk to visit, she would take family snapshots.

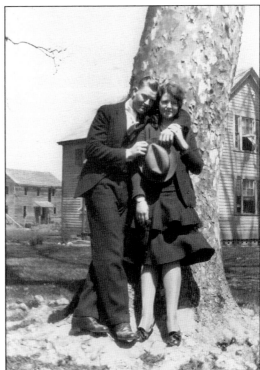

Mary Smith Hassell (1911–?) was living in Norfolk, Virginia, when her father George died in 1930. Mary is pictured here in her funeral attire with her cousin, Winton Sawyer. By that time, the old Plantation Hospital had been stripped of its windows and chimneys as if it were ready to be moved to another location.

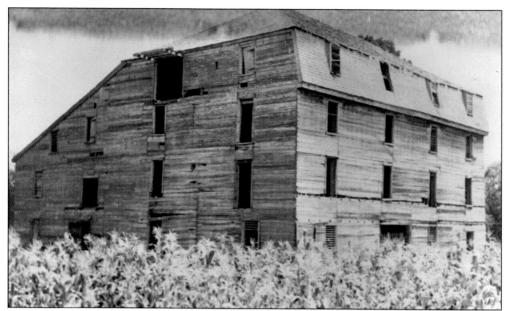

Before 1791, the plantation's earliest enslaved laborers built Somerset's four-story "Great Barn." It was made of hand-hewn cypress, measured 73 feet long and 42 feet wide, and had sills up to 15 inches square. The uncommon size of the barn serves as a testimonial to the number of cultivated fields and diversity of crops produced on the plantation, including rice, corn, hay, oats, wheat, and barley. Farm animals and equipment were housed on the first floor. A grain elevator moved crops to the top floors. The barn burned to the ground in 1949.

During the 1920s, slave descendants and poor whites alike hired themselves out as day laborers for any farmer who could afford to pay a small wage. Though farm tractors had been invented, most of Creswell's fields were still plowed by man and mule. This picture, snapped around 1922, appears to be a "show-and-tell" photograph meant to document just how many men and mules there were in the farming work force.

Washington "Wash" Webb (1894–1935) "funeralized" folks for a living. No embalming, just the burying kind of funeralizing. When someone died, he or she was put in one of Wash Webb's custom-made caskets. The next day the casket traveled first to the church, then to its final resting place in Webb's stylish and shiny top-of-the-line, white, 1926 Model T Ford hearse. Between funerals, he supplemented his income working as a blacksmith. Wash and his wife, Virginia Pailen (1884–1943), had no children, but they showered family and friends with their bounty.

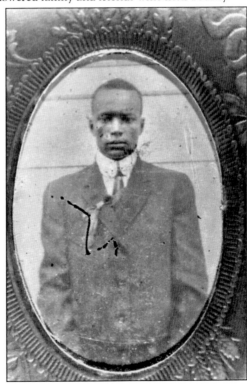

This c. 1910 tintype of Walter Benjamin Fenner (1895–1980) has "in his blue serge suit" written on the back. The new suit may have inspired the picture. Walter married twice, first to Mamie Alexander (1899–1926), then Essie Davenport (1897–1979). He was the father of four: Fleetwood, Leroy, Endia, and Iva Gray.

Richard Riddick Honablue remembered that, when he was a little boy, his grandmother, Betsy Spruill Riddick (1844–1934), wife of Richard Riddick (1842–1917), prepared an evening meal and served it from a large carved tray positioned in the middle of the table in the African tradition. This picture of Grandma Betsy was taken around 1927. She is seated on the porch of her Creswell home. As was the custom, a part of her daily wear was the long apron protecting the front of her skirt.

After graduating from the Creswell Colored School, Willie Augustus Riddick (1894–1953) went to State Normal School, now Elizabeth City State University, so that he could be a schoolteacher. By the 1890s, tiny one-room schools dotted the landscape of former plantations around Creswell. There was no transportation to a central school. This photograph of Reverend Riddick was snapped in 1938, while visiting a home in his capacity as a minister. Reverend Riddick also was a blacksmith and carpenter. He and his wife, Mildred Spencer Riddick, had five children.

In 1920, any student wanting more than a seventh-grade education could board with a private family and attend Dunbar High School in Elizabeth City. By 1932, when Clara Jenkins Preston's class donned their caps and gowns, they were graduated from the 12th grade and were required to go to college before they could become teachers.

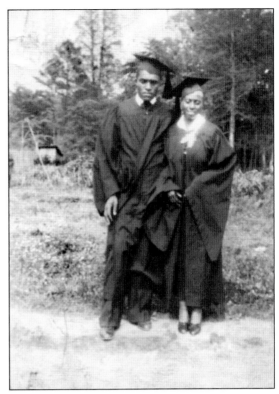

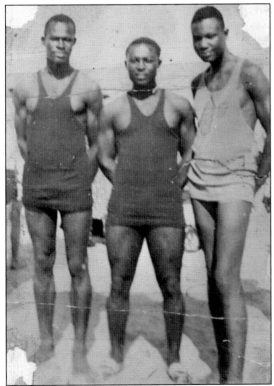

"I'm gonna' skin your legs alive," was a threat heard at some point in time by every child in the second generation born free. By around 1933, the "old heads" (the first generation born free) would have had a field day when many of the young folks from Creswell and Columbia ventured north and posed showing all the legs God gave them. This crew—James Edward Littlejohn (1912–1979), Eddie Jenkins (1906–1960), and Fred Irving Littlejohn (1906–1986)—settled in Queens, New York, with easy access to places like Jones Beach and Coney Island.

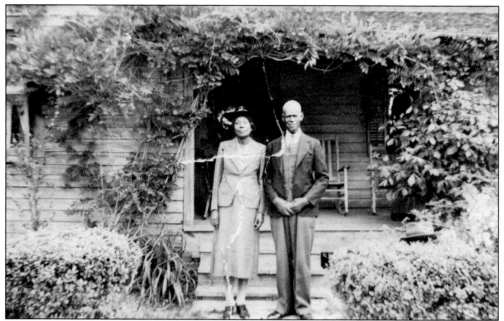

Rev. James Edward Littlejohn (1879–1944) may not have promised Jechonias Jenkins (1890–1978) a vine-covered cottage, but by 1942, that is exactly what she and their four children had.

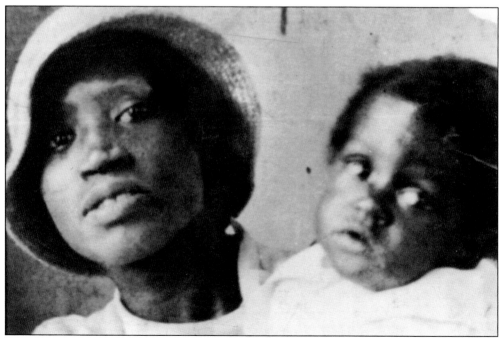

Eddie Louise Littlejohn Spruill (1908–1994), wife of Grady William Spruill (1908–1998), had her first of seven children, a son she named Fred, in 1932 and posed with her new baby on a Sunday after church.

By 1937, 75-year-old Jenny Bryant Alexander (1862–1947), born in the midst of the Civil War, was situated on her own land and posed for this snapshot near one of three gardens she maintained. She would fill a foot tub with ashes from the household stoves, carry it on her shoulder, and "spread the ashes in her garden like fertilizer." She always had more flowers and vegetables than they needed for the stock and their table. There was nothing fancy about Jenny Alexander; she dressed in work clothes, including high-top brogans and the traditional white apron that protected the front of her skirt.

Victoria Dunbar (1908–1991), wife of Lloyd Dunbar, and her four-year-old son Arthur (1932–1999) and baby, James William "Piggy" Dunbar (1937–1994), also posed for a snapshot in Jenny Alexander's yard. Mother and sons all lived into the 1990s and died within eight years of one another. This unplanned snapshot capturing a moment in time is the only picture they took together.

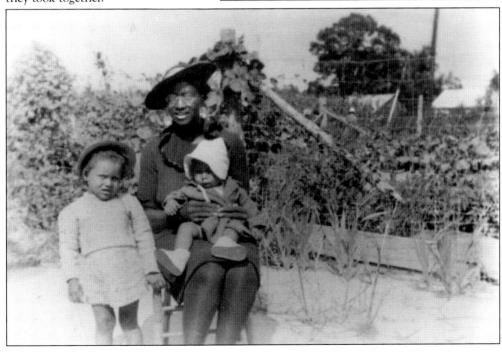

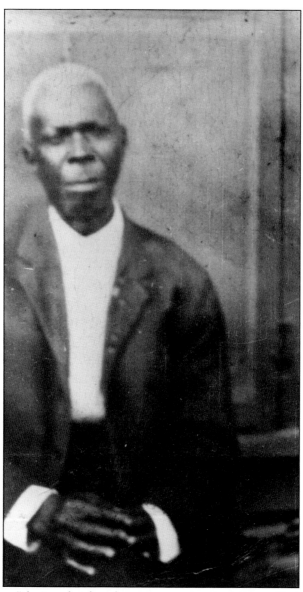

"Just follow the finger" (or just do what the overseer pointed to) is how Darious "Ross" Bennett (1854–1948) characterized interactions between Somerset's overseers and young slaves when he talked with his son Ludie about slavery. Darious remembered when a horn blew and slaves were told the Civil War was over. He also described the fancy hat the Collinses' coachman, Wellington Roberts, wore. In 1938, *North Carolina State Magazine* found Mr. Bennett living in a one-room house in the backyard of the white Harris family in Creswell. He paid his keep and maintained his independence repairing shoes and picking up around the place. In exchange, the Harris family provided a roof over his head, meals, and a little money. Each Christmas, the Harris children gave Mr. Bennett a brand-new white shirt. Mr. Bennett promptly lifted the top of his old wooden trunk, took out the shirt given the previous year to wear, and stored the new one. When asked, he explained to the Harris children his reason was "nonna yo business." How could he tell the children that he was saving his new shirt so he would be properly dressed for his coffin when he went to meet his maker?

The 1934 Sears catalog advertised the suit this dapper 32-year-old William Leslie Fenner (1902–1981) is wearing for $18.95. At that time, Leslie lived in Creswell and worked the family land. But when it was dress-up time, his appearance gave no hint that he was a farmer.

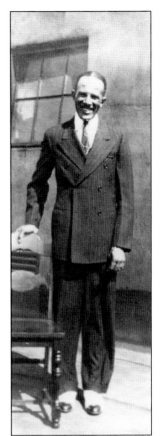

William Leslie Fenner remained in Creswell as long as his parents lived and supported their dream of having productive land, but his heart was always in the big city. In his 50s, he moved to Queens, New York, and eventually got a job as a laborer on the railroad in the Bronx. Still dapper in 1957 at age 55, he went into a studio there and had this picture taken to send to family in Creswell. The New York studio was equipped with three-dimensional props.

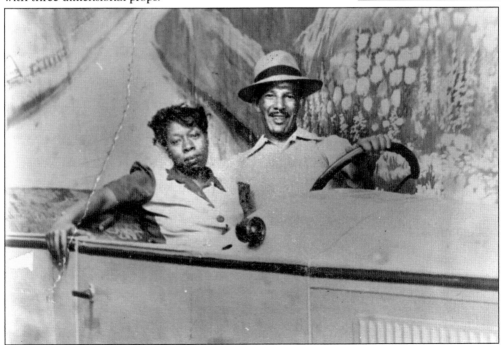

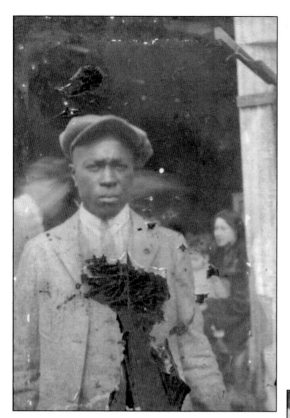

Pictured here is one of Creswell's sons, Johnny Davenport, son of James and Charlotte Roberts Davenport and a descendant of native Africans Guinea Jack and Fanny Collins.

During the 1930s, Dempsey and Amy Fenner owned a camera and began taking snapshots of nearly every relative they had. They also took pictures of the family mules. Here their daughter Hulda Mae Fenner (1897–1940) poses casually in the yard of her family home.

In this snapshot, an unidentified member of the Fenner family is positioned to show off the rather substantial Fenner family home.

A young Jupiter Pailen also poses with the family home on Main Street, just outside of the Creswell town limits in the background. All of the houses had screens on the doors only. It was the custom to cover the parlor furniture with sheets during the summer, to prevent the dust from unpaved streets from settling on the furniture. Almost all of the homes standing during the 1940s have been razed and can only be seen in photographs.

This 1943 photograph of Chief Hiram A. Bennett (1922–1973) says, "To my family with best Wishes." Hiram was born in Norfolk, Virginia, where his parents, Johnson and Betty Bennett, settled after leaving Creswell. Later the entire family moved to Brooklyn, New York, where Hiram died. He was on active duty in the U.S. Navy from 1942 until his death.

Nathaniel Pettigrew Bennett (1925–1975) answered the call to arms during World War II. After returning to civilian life, Nathaniel became a federal postal employee and was superintendent of a post office in Queens, New York, at the time of his untimely death at age 49.

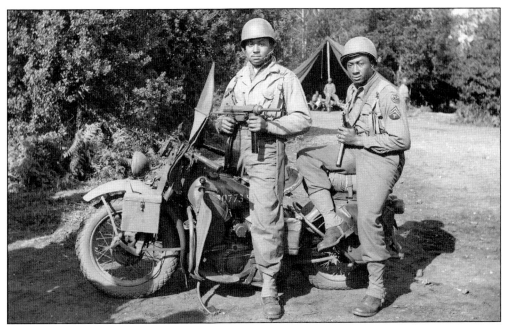

No official army photographer could compete with the creative image of soldiering snapped by Cpl. Thurston Honeyblue (1916–1984) for family back in Creswell: full field dress, weapons drawn and aimed, perched aboard a fully equipped one-seater motorcycle, with a facial expression that says "bring it on." On the back describing the soldier to the left, Thurston wrote, "Cpl. John Foster, Louisburg, North Carolina. This is my friend."

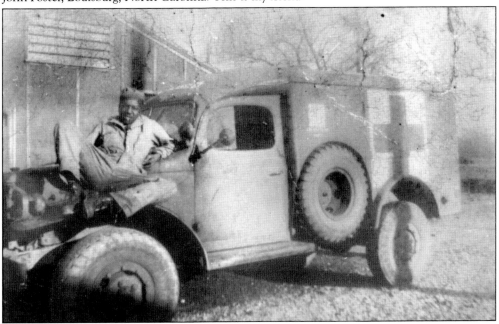

Many World War II soldiers enjoyed having snapshots made that included military vehicles or other equipment. Here Irvin Honablew (1912–1992), posed atop an army ambulance, was surely set on impressing his wife, Mary Lizzie Spruill Honablew (born 1923) and their baby daughter, Alberta, who was born in 1943.

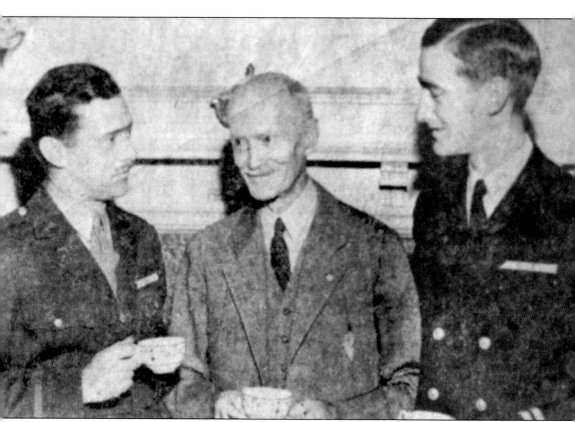

For many families, including that of Josiah Collins V, World War II was a family affair. This picture shows Josiah Collins V (center) with his sons Maj. Josiah Collins VI (left), who was serving in Alaska, and Lt. Wetherill Collins (right), who was assigned to the South Pacific. Both of the sons happened to arrive home for leave at the same time, making this happy reunion possible. (Photograph by the *Seattle Post-Intelligencer*.)

Johnson Bennett Jr. (1917–1976) and George
Hickman Bennett (1915–1985) were among six
sons born to Johnson Sr. and Belvey L. Butler
Bennett. Five of their sons, including Johnson and
George (although not pictured in uniform), went
to war during World War II.

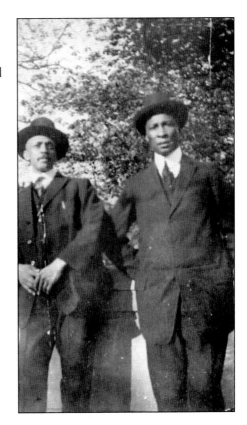

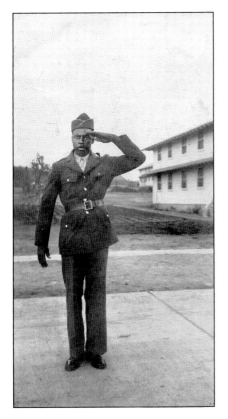

George Alfred Roberts (1919–1983) was the kind of
fellow who always kept everyone laughing. Once, after
attending an unusually high number of family funerals
in one year, George arrived for the latest, fell to his
knees, and announced that he had cried clean out
of tears. He said, "I had to borrow some tears for this
funeral." George was deadly serious about his World
War II military service, however, and was honorably
discharged in 1945. All assume the negative was
reversed in this, his only, military picture.

83

Brothers Roy (left) and Jay Owens had the good fortune of taking a World War II snapshot together for family members back home. They are positioned to include an army vehicle.

In contrast, this unidentified childhood friend of Mable Pailen chose an exotic jungle terrain, which included a fierce tiger and a spear as his weapon of choice. This had to bring a smile to the faces of family and friends back home in Creswell.

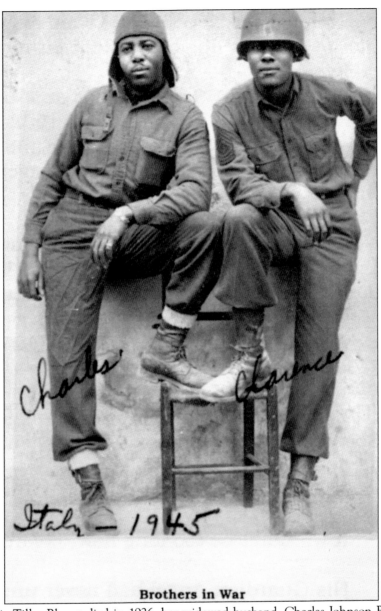

Brothers in War

When Lillie Tiller Blount died in 1926, her widowed husband, Charles Johnson Blount, and their four children began farming cotton on a relative's farm. Then during the Depression, he moved his family to Baltimore where his son Clarence remembered getting his first pair of shoes. "I wanted to wear them to bed," he once said. At nine years old, Clarence W. Blount (1921–2003) entered the first grade in the Baltimore City Schools, and for the next 74 years, learning, teaching, and learning more defined his life. His tenure at Morgan State University was interrupted in 1945, when he and his brother Charles (pictured here) were drafted and served together in Italy. He returned to Baltimore and graduated magna cum laude from Morgan State, received a law degree from Johns Hopkins University, and completed four years of doctoral course work at George Washington University. Maryland state Senate Majority Leader Clarence W. Blount was an attorney, public school principal, and college professor. He fulfilled all of the deferred dreams his enslaved ancestors could imagine.

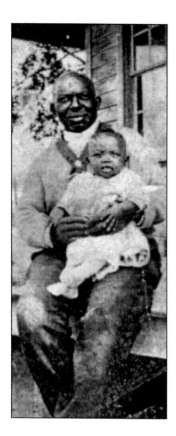

No parents could have been happier than Willie Lee and Esther Bennett Alexander when their daughter, Barbara Ann Alexander Howard (1942–1982), was born. In this 1942 snapshot, Willie Lee Alexander and daughter have the same smile and gleam in their eyes.

It was of immeasurable importance for black and white families living in and around the towns near Somerset Place to have an upright piano in the living room. There as elsewhere, a prominently displayed piano often was a symbol of middle-class status or striving. There were no music stores nearby, but traveling salesmen visited households offering long credit contracts with small payments. Soon thereafter, the piano arrived by train. This c. 1948 snapshot from the Lonnie Spruill collection centers on the family piano.

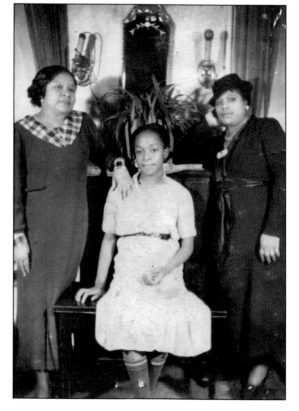

86

Joyce Louise "Aunt Honey" Honeyblue (1890–1949), daughter of Elijah (1862–1930) and Judith Littlejohn (1866–1922) Honeyblue, never married. She became a member of the first generation in her family to abandon Creswell and head north. With the exception of farm work and housework, single women could not earn a living and support themselves.

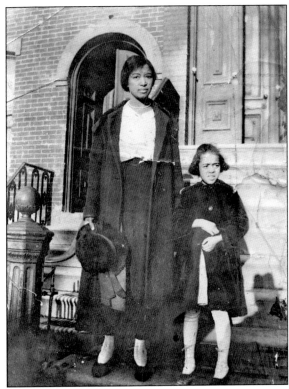

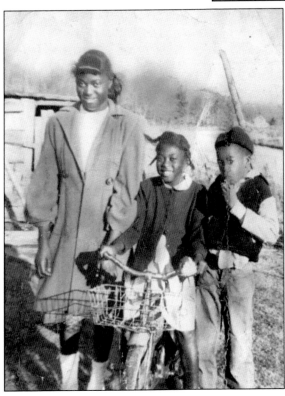

Snapshots captured special events. Emma Pledger, Thelma Leigh, and Lonnie Harris Jr. pose in the backyard along with Thelma's new bicycle.

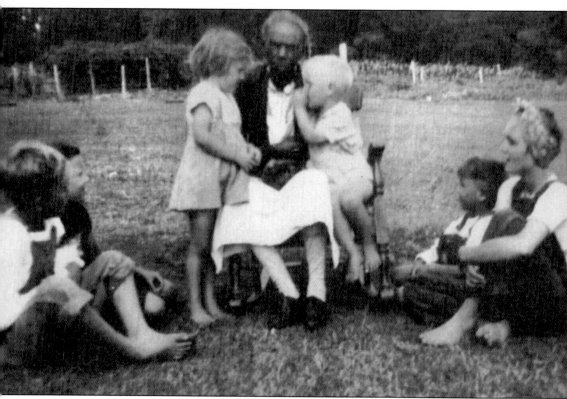

During her lifetime, Henrietta Hill Davenport Paige (1870–1948) delivered more babies than all other Creswell midwives combined. She married Africa Davenport. A part of her attraction to him was that Henrietta Hill loved to dance and Africa played the fiddle. She had 12 children of her own to care for but never failed to answer the call of another mother about to deliver. Expectant fathers came to fetch her day or night. She grabbed her big denim bag filled with two wash pans, plenty of gauze, a bottle of Lysol, and some secret medicines known only to Henrietta. Some local children thought she brought the baby in the bag. The custom then was that the mother remained in bed for nine days. It took almost that long for the baby to open its eyes. This photograph was snapped in 1946, just two years before she died, with some of the children she delivered surrounding her; from left to right, shown are Frank, Janice, Barbara, Henrietta, Bill, Herbert, and Doris, children of McCoy and Dorothy Phelps Davenport. Henrietta Hill Davenport Paige was highly respected by citizens of both races.

Six

SNAPSHOTS
Since 1951

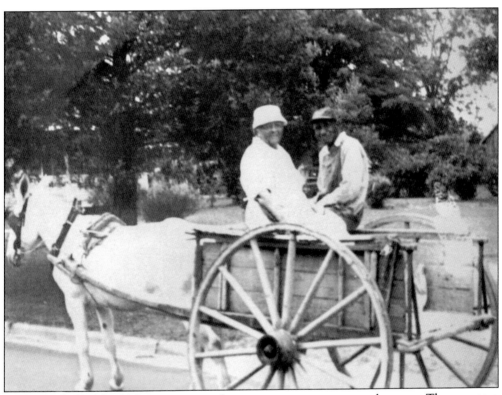

By the last half of the 20th century, snapshots were more spontaneous than ever. They preserve both daily life among ordinary folks and novel situations. In 1952 Creswell, the contrast of mule and cart against the backdrop of paved roads with curbs and gutters is striking. Luther Riddick (1886–?) "called himself liking" widow woman Miss Elizabeth "Lizzie" Alexander Owens (1888–1985) and riding her through town in his mule and cart was just a part of his courting style.

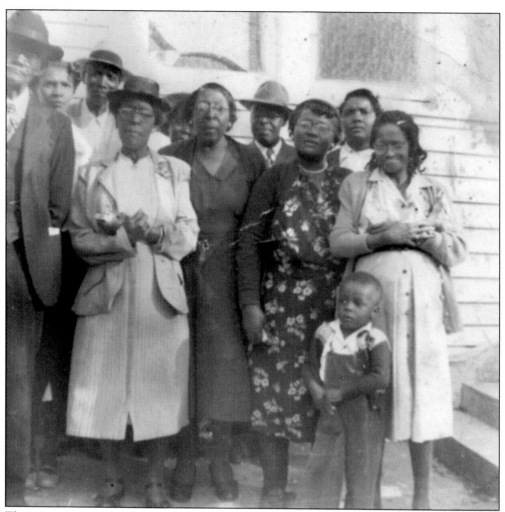

This picture was taken on Easter Sunday morning April 14, 1952, at St. Mark A.M.E. Zion Church. The church was built on land donated by early black landholders Jenny and Washington Harvey Bennett. The initial trustees were all former Somerset Place slaves, whose fine, two-story edifice had rules to live by: no walking across the pulpit, and no talking above a whisper in the sanctuary unless you got "happy." Folks say the early church members had code phrases to describe folks who did not measure up to their standards of "pure living and right thinking." For instance, only "a nasty stinkin' strumpet" talked back to grown folks. A "low-lifeted trifling dawg" didn't support his family, and a "John Brown pison joker" or "a blaze-faceded-heffa" lied to church folk. Shown here, from left to right, are (first row) Rev. James Simpson, Janie Knowles Simpson, Miss Alice Dixon, Mary Norman, Mary "Babe" Harris, and little Thurston Honeyblue; (second row) Martha Ann Webb Leigh, Herbert Creecy, Mary Rose, Prof. Peter Wallace Littlejohn, and Mable Pailen Spruill.

Borrowing from the musical *Oklahoma,* the corn grown in and around Somerset Place in 1952 was "as high as an elephant's eye." Pictured here are Samuel Augustus "Rabbit" Davenport (left), his boss Zephaniah Henderson Phelps Jr., and Phelps's son Charles Lavern Phelps. The lens of the camera has preserved this exceptional crop of corn for always.

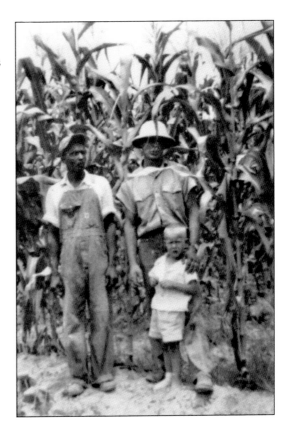

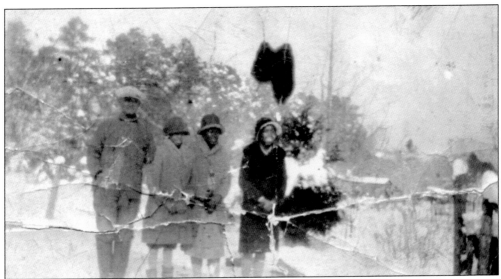

You can almost hear Haywood Leigh saying, "I've got to get a picture of this." A once-in-a-lifetime winter blizzard hit Creswell in the early 1950s, and several families preserved the event in pictures. When they revisit the pictures, everyone has a lifelong "big snow" story to tell.

Clara Preston's 1954 snapshot captured a backyard scene that most people who lived in small rural towns before the 1970s can remember. The chicken house and fenced chicken yard, the black cast iron "washpot" used for heating water and boiling white clothes in, and the long clothesline prop. Still awaiting public utilities, no backyard was complete without a hand-pumped water pump and a one-seat outhouse.

Arthur Collins, son of Josiah III and Mary Collins, had a home built for himself on the Weston Farm of Somerset Place in 1875. He also had tenant houses built for the black and white families who worked for him. This photograph, taken in 1952, includes one of Arthur's tenant houses that ex-slaves Johnny (born 1861) and Ida Davis lived in.

Llewellyn Pailen (1881–1969) inherited a couple of town lots from his father. But once you left the two-block-long commercial district of the town of Creswell, all of the town lots became small farms fully equipped with gardens, farm animals, and barns. In this snapshot taken in 1954, Douglas Spruill, with his grandfather Llewellyn, is of the men's domain. The backyard barn is where anything possible was stored.

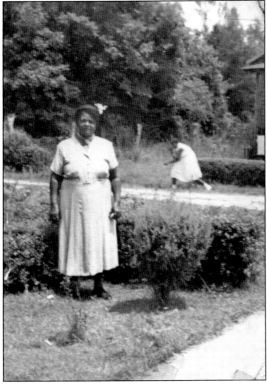

Said to be a full-blooded Indian, Mary Elizabeth Barber (1887–1988) came to Creswell from Hyde County, North Carolina, to work as a housekeeper. She soon met and married Llewellyn Pailen and had one child, Ruby Mable Pailen Owens Spruill. Ruby gave them four grandchildren, one of whom, Barbara Spruill Leary, could not resist dashing through this picture taken of her grandmother in 1954.

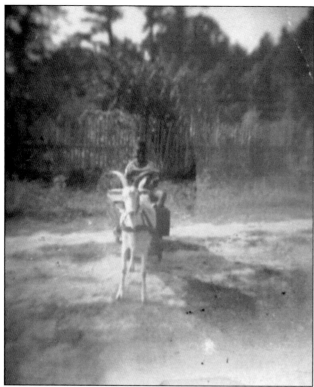

Is it possible that the goat is thinking, "Have you folks ever heard of cars?" Llewellyn Pailen trained this, his prized white goat, from the time it was a baby to be hitched to a cart and transport his grandchildren up and down the streets of Creswell. The goat is seen here pulling Douglas Spruill in 1954.

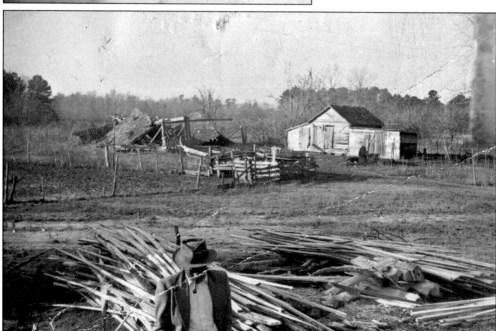

Reputedly the wood piled in the foreground of this c. 1954 snapshot of Llewellyn Pailen's back yard is fencing. Pieces of wood were individually driven into the ground and wired together with barely any space between them. This kind of fencing was still used by older folks living in the town limits of Creswell to close in chicken yards.

Seven

GENERATIONS OF SOMERSET PLACE TODAY
A Homecoming

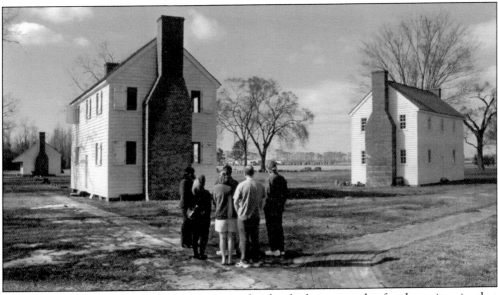

Today Somerset Place State Historic Site is said to be the best example of a plantation site that recognizes and values equally the history, heritage, and cultural traditions of all of the plantation's former residents. Movement toward full inclusion of African American history began in 1986 when more than 2,000 descendants of slaves and slave owners gathered on the grounds of the plantation for an unprecedented celebration of family and life called Homecoming. The historic and culturally affirming event made it impossible to ignore the site's historic black presence. This chapter presents Homecoming images, including some family group pictures. Emphasis is placed on family pictures that include the second generations in each family born after the Civil War—a generation in which almost all of the elders passed away within the 10 years following the 1986 Homecoming.

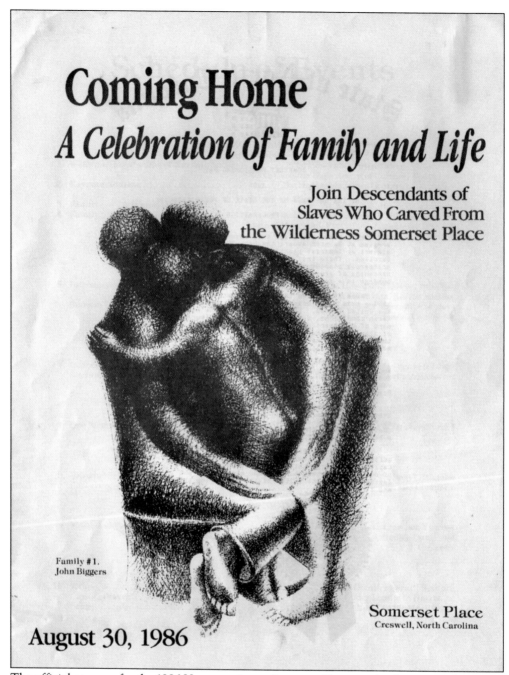

Coming Home
A Celebration of Family and Life

Join Descendants of Slaves Who Carved From the Wilderness Somerset Place

Family #1.
John Biggers

Somerset Place
Creswell, North Carolina

August 30, 1986

The official program for the 1986 Homecoming at Somerset Place carries the image of premiere African American artist John Biggers's *Family #1*, symbolic of the concept that family is number one.

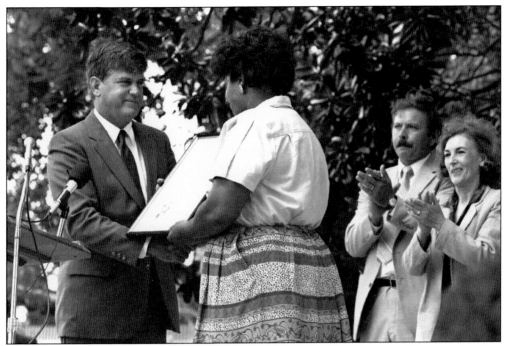

Homecoming organizer Dorothy Spruill Redford receives the 1986 Somerset Homecoming Day proclamation from North Carolina governor James G. Martin as Patric Dorcey, secretary of the North Carolina Department of Cultural Resources, and Thomas Holmes, a Washington County commissioner, look on.

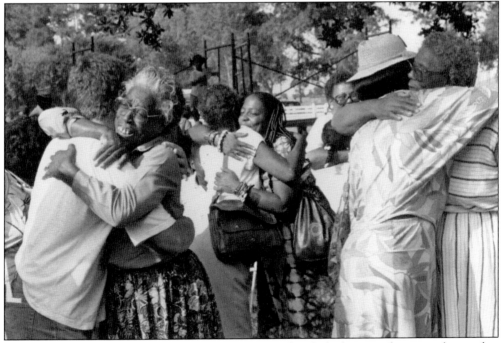

Descendants and friends from near and far were greeted with the kisses and warm embraces that characterized the day.

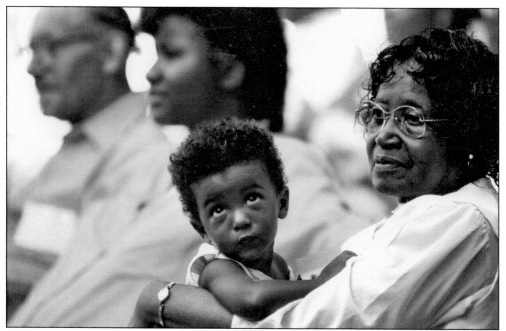

The 1986 Homecoming was a celebration of family. Pictured here, from left to right, are the family of Dorothy Spruill Redford: father, Grady W. Spruill; daughter, Deborah Reid-Murphy; mother, Louise Littlejohn Spruill; and first grandchild, Julyen James Murphy. Little Julyen and his great-grandmother, Louise Spruill, represent the oldest and youngest generations in their line.

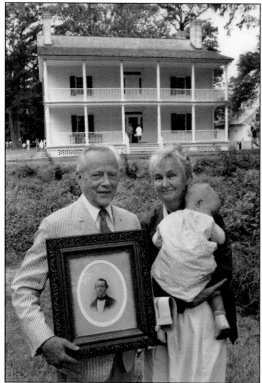

Pictured here from left to right are Josiah Collins IV; his cousin, Frances Drane Inglis; and her granddaughter, Alice Inglis Whiteside. Josiah Collins IV is holding a picture of his ancestor Josiah Collins III, who once owned Somerset Place. Little Alice and Josiah VI represent the oldest and youngest generations in their line. (Photograph by Time Inc.)

Alex Haley, celebrated author of *Roots*, graciously paid a surprise visit during the 1986 Homecoming. Genealogical research on members of the plantation's enslaved community and their descendants was undertaken by Dorothy Spruill Redford after seeing the televised mini-series *Roots*. The Homecoming was an outgrowth of her genealogical research. Here her hero, Alex Haley, gives congratulations and words of encouragement to Redford. (Photograph by *People Weekly*.)

Somerset descendant and Maryland state senator Clarence Blount welcomed family and visitors. He expressed his overwhelming pride in his enslaved ancestors and joy at knowing from whence they came. He said to other descendants, "We are from the strongest of the strong—the survivors."

Descendants relax in the shade of vine-covered trees and take in the sights and sounds.

Welcoming yellow ribbons and family names greeted descendants. Here family members stand before the same 350-year-old bald cypress their earliest enslaved ancestors stood before. For many, touching trees their ancestors might have touched proved a powerful experience.

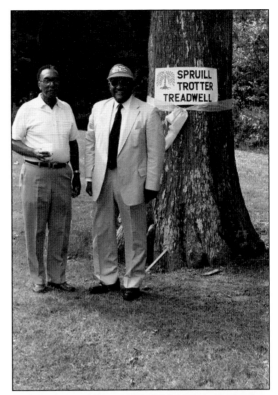

New York descendants rode a bus with some mechanical problems all night, gratefully experienced all that the day at their ancestral home offered, and then got back on the same mechanically challenged bus to ride all night again to get home. They said, "We had to be here." Their hand-painted banner proudly declared, "Our Roots Are In Somerset."

Doubleday published *Somerset Homecoming: Recovering A Lost Heritage,* by Dorothy Spruill Redford with Michael D'Orso, and an introduction by Alex Haley in 1988. The book chronicles Redford's journey to connect slave descendants to their enslaved Somerset Place ancestors. The book was released to coincide with the 1988 Homecoming at Somerset Place. Seen here, Redford sports her "Feeling Good About Life" t-shirt. *Somerset Homecoming* has been republished by the University of North Carolina Press.

Jacqueline Kennedy Onassis served as the editor for *Somerset Homecoming.* Reflective of her considerable warmth is this letter to Redford about the 1988 Homecoming:

September 20
Dear Dorothy,
 I want to congratulate you on your magnificent book—the dream come true at last!
 You worked so hard and it is so moving. Judy told me all about the reunion, which must have been a joyous emotional experience. If I hadn't been moving my Caroline and her new baby into our house for the summer, how I would have loved to be there.
 I hope you are so happy and so proud. You deserve to be.
With admiration and affection,
Always your friend
Jackie.

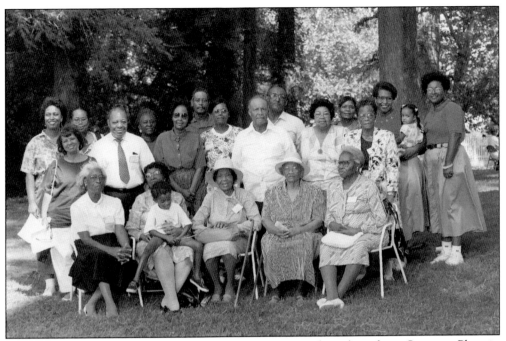

James Madison Baum (1808–1845) was born in Virginia and was brought to Somerset Place in 1829, where he married Diana Bennett Baum (1811–1860). He was the only slave at Somerset with the Baum surname, and all the Baum descendants pictured here are his.

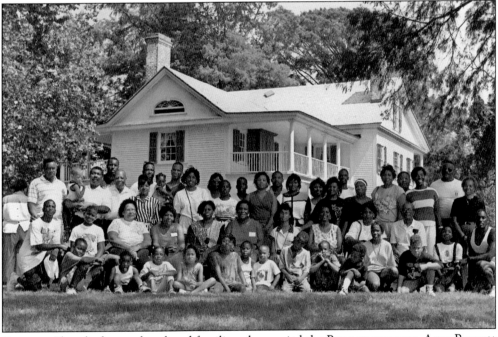

Somerset Place had several enslaved families who carried the Bennett surname. Aggy Bennett (1774–1840) was Somerset's first known slave to carry the surname. She had one son, named Nelson (born 1829). According to the plantation records, at age 68, Aggy married 36-year-old Dave Bartlett (born 1803). Pictured here are Bennett's descendants.

This family photograph, taken in 1988, captures the first through the fifth generation in Ludie Bennett's family born free. It illustrates that, in terms of generations, America is not terribly far removed from the institution of slavery.

The Dunbar/Hill/McCleese family group blends local Native American and emancipated African American lines. From the time they arrived in the area, the Hills were listed as free. Family tradition says they were American Indians. After freedom came, the Hills intermarried with former Somerset slaves.

The "Feeling Good about Life" t-shirt captures and reflects the sentiments of African Americans attending the 1988 Somerset Homecoming. Knowing the starting point enabled all to feel good about how far they had come and to appreciate the strength of their ancestors.

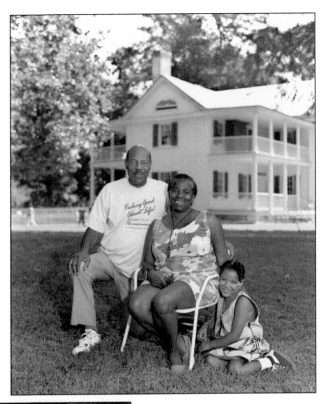

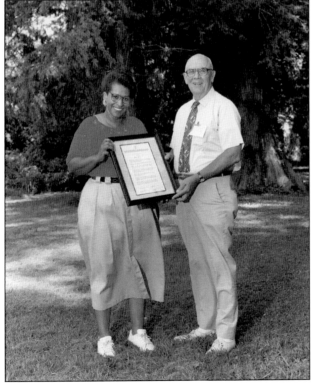

State Rep. Howard Chapin receives an award from the Somerset Place Foundation, Inc., for his unwavering legislative and personal support of projects at Somerset Place. For more than 10 years, Representative Chapin chaired the Somerset Place Foundation, Inc.

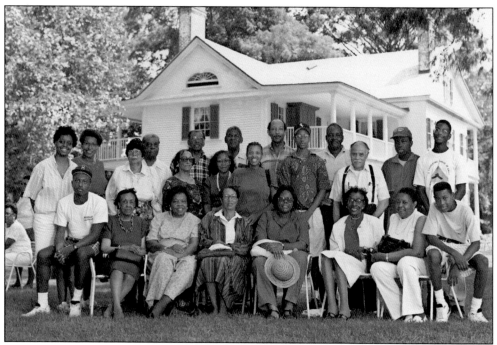

The Honeyblue/Honeyblew/Honablue family is shown here. Their lineage is rooted in Guinea Jack and Fanny Collins, two native Africans brought to Somerset Place in 1786. Many of the Africans perished under the backbreaking tasks of clearing centuries-old trees and digging drainage canals.

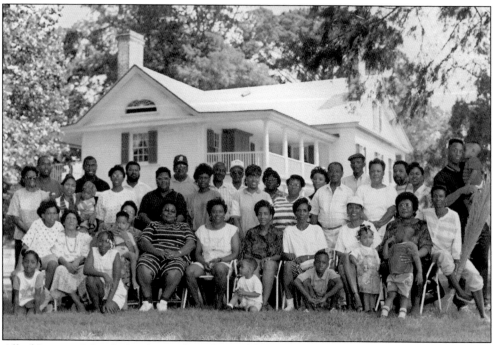

All of Somerset's Leigh family members descend from Hiram (1831–before 1910) and Mary Jane Hall (1836–before 1910) Leigh. They are what the old folk described as "all kinned up."

106

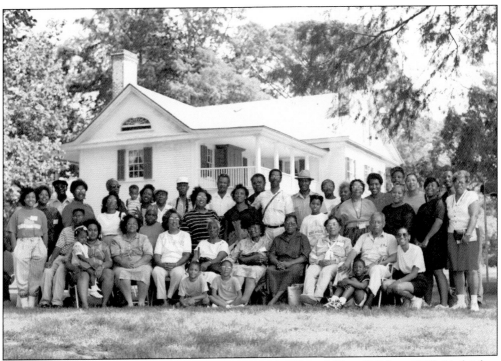

Somerset's Littlejohns descend from Peter (1785–c. 1855) and Elsie (1796–c. 1870) Littlejohn. Peter and Elsie both were sold in 1853 for reputedly being involved in an attempt to poison Somerset's overseer.

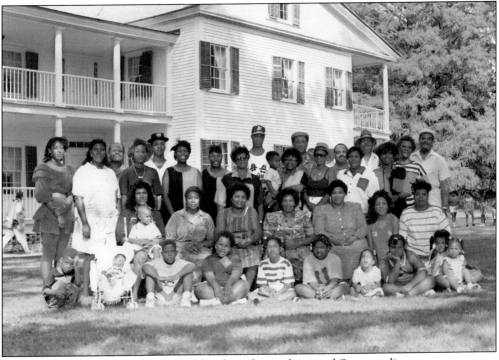

The Norman family consists of allied families of several original Somerset lines.

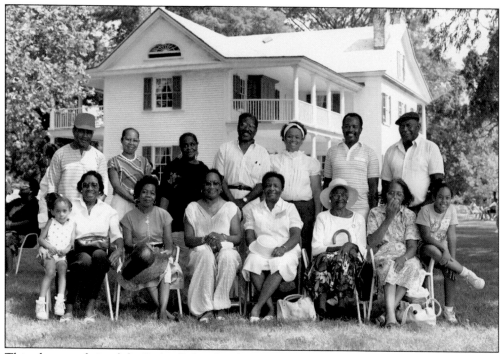

This photograph is of the Pailen/Palen family group. Somerset's first Pailen, Jupiter, was born in 1764. His first union was with a native African called Donkey (an anglicized version of the Akan word "Dunko"). The name Jupiter has appeared in every generation of this family from 1764 through 2005.

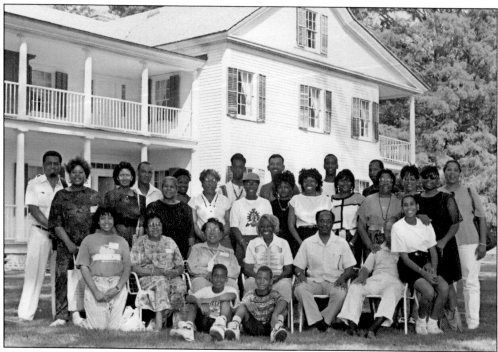

The Robertses trace their lineage to native Africans Guinea Jack and Fanny Collins.

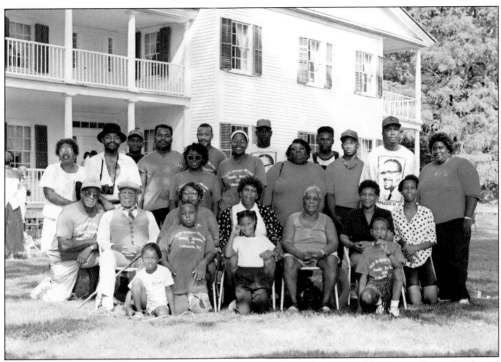

The Sawyer family's first ancestor was a hog tender called "Doctor Jack" Sawyer (born 1793) and his wife, Betty Collins (born 1797).

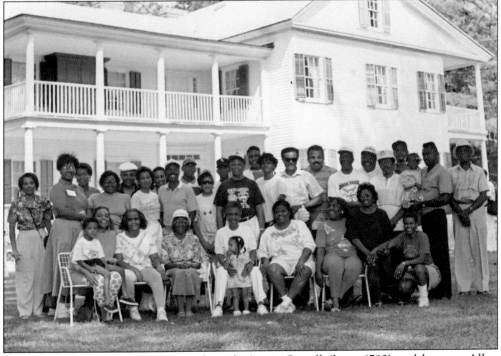

Somerset's Spruill family connects through Annie Spruill (born 1790) and her son Allen (born 1812).

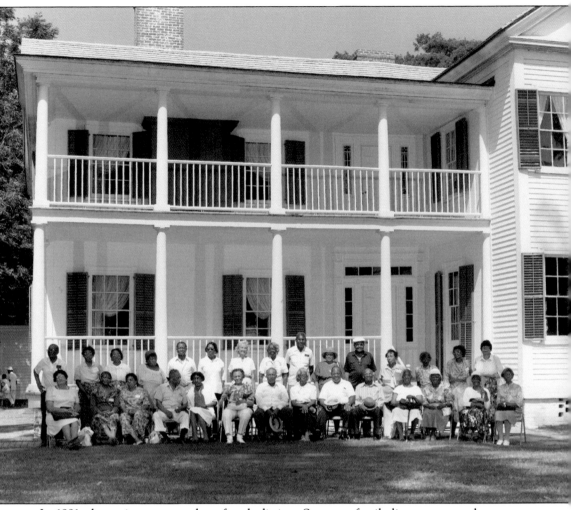

In 1991, the senior-most member of each distinct Somerset family line came together to pose for this photograph. It is noteworthy that included are representatives of Somerset's owners and enslaved community.

Eight

GENERATIONS OF SOMERSET PLACE TODAY
Passing History On

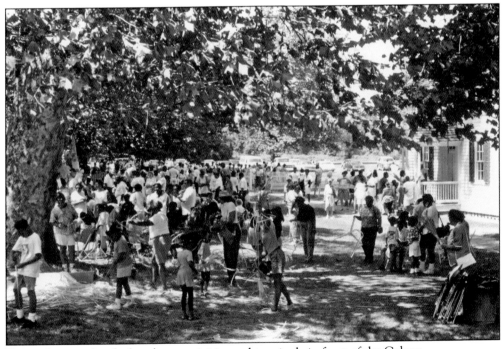

Descendants gather for hands-on activities and to mingle in front of the Colony.

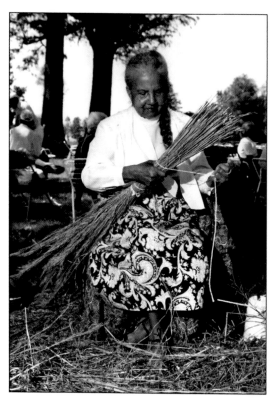

Passing on traditions, Somerset descendant Sylvia Hunter demonstrates making sedge brooms. She made and used them as a child to sweep her home and yard. (Photograph by Jim Stratford.)

Storyteller Lloyd Wilson intrigues youngsters with his "Hi John De Conqueror" tales. (Photograph by Jim Stratford.)

From left to right, Orinalde Qunijimai, J. C. Carter, and Clarence Vincent ask the blessings of the ancestors using a sacred drum call.

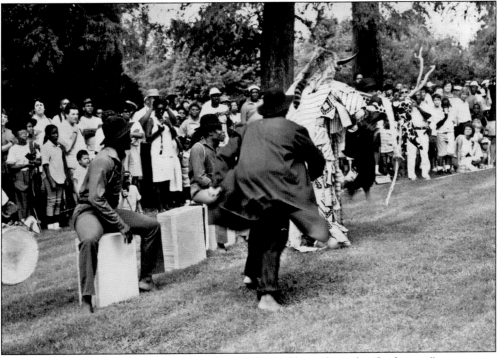

Chuck Davis and the African American Dance Ensemble perform the "Jonkonnu," a ceremony witnessed at Somerset Place during the 1840s.

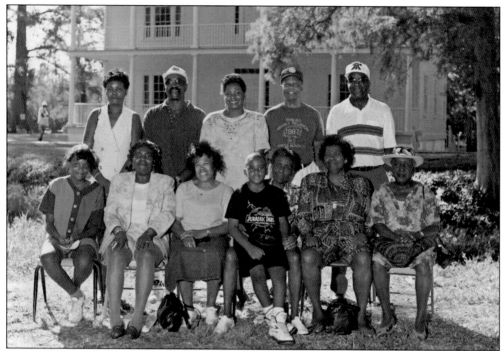

Lonnie and Lillie Mae Meyers Spruill were members of the first generation in their families born free. Determined to shed any and all vestiges of slavery, their children, pictured here, were reared in Creswell's grandest black-owned home. Five of their eight spacious rooms were bedrooms. Lillie Mae Myers, a well-read woman, named one of her daughters after Harriet Beecher Stowe.

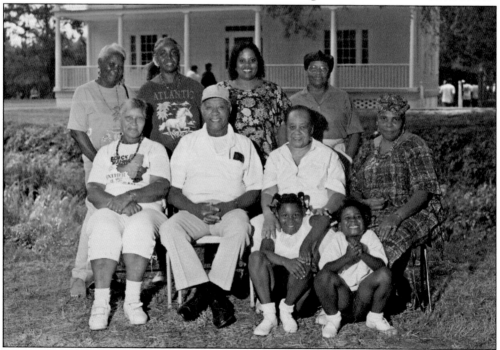

This picture captures the descendants of Jupiter and Lucreecy Phelps Pailen.

Josiah III and Mary Riggs Collins's descendants came from the states of Oregon and Washington in 1996 to join in the Homecoming at Somerset Place.

Picture here are the descendants of Melvin and Catherine (Kate) Collins Dickerson.

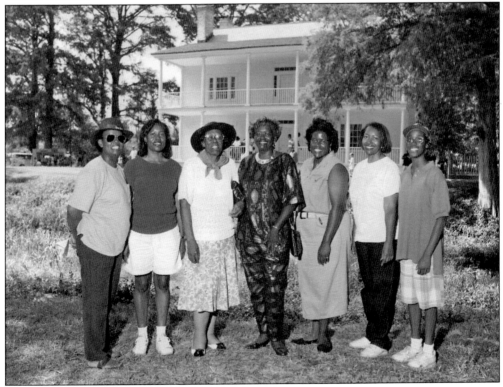

This child plays hide and seek while standing on the roots of a magnificent sycamore tree one of his ancestors may have planted in 1856. He is connecting with physical and genealogical roots.

Seemingly oblivious to what's going on around them, this elder and child share a poignant loving moment with one another.

Tracey Burns-Vann demonstrates broom making to an attentive audience of young people.

Sylvia Whitford helps her student make a small woven basket.

The New York–based Marie Brooks Dance Theatre performs at the 1993 Somerset Homecoming.

Master potter Carol Lee helps her young charge on the potter's wheel.

This photograph is of all the Owens/Spruill/Pailen family related by blood or marriage.

The Alfred Littlejohn line at Somerset was among the plantation's most defiant family groups. His aged grandparents, along with some uncles and aunts, were sold for reputedly attempting to poison the plantation's overseer, and Alfred himself ran away in 1862. Pictured here are his descendants.

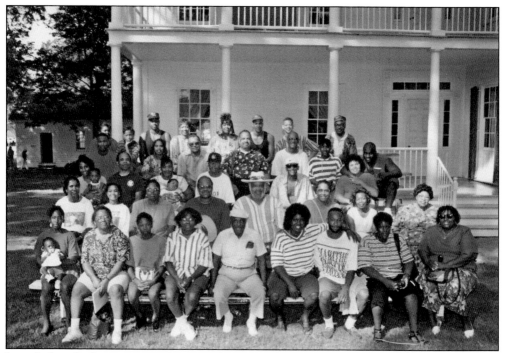

Long before the homecomings began at Somerset Place, this group of Baum descendants held family reunions that all family elders looked forward to. The Somerset Homecoming, however, provided a forum for them to reconnect with the community of folks they had grown up with.

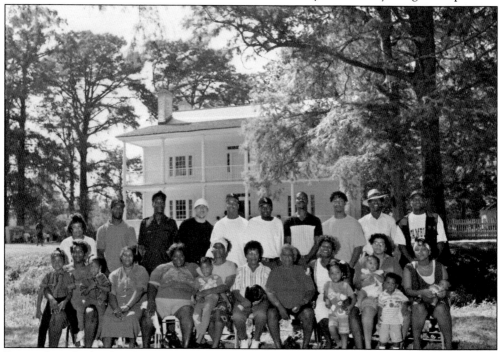

Descendants Richard and Rubell Sawyer pose in their last family group photograph to include their mother.

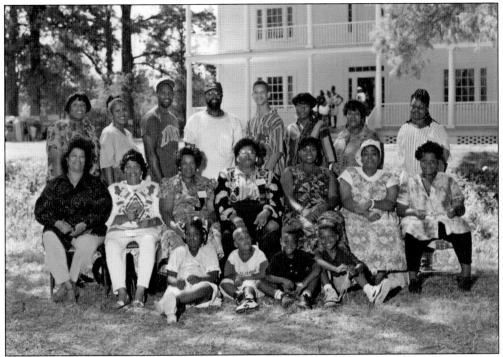

The Norman family, whose descendants are pictured here, settled in the Pea Ridge community, about 10 miles from Somerset Place. There they became founding members of Shiloh Disciples of Christ Church.

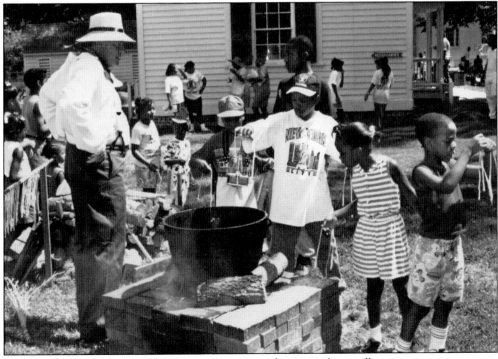

Jerry Raveling teaches youthful Homecoming attendees to make candles.

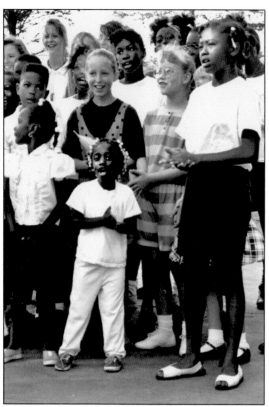

In 1993, children representing most of Creswell's churches performed for the Homecoming crowd.

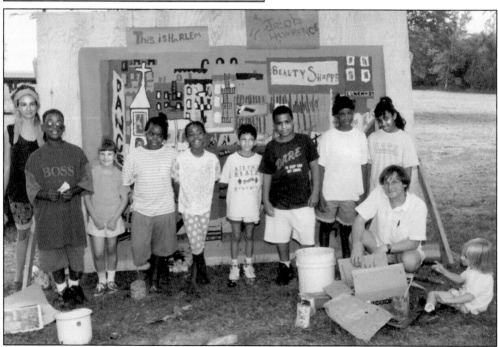

Students attending the homecoming gain appreciation for African American art by creating their own mural.

Nine

GENERATIONS OF SOMERSET PLACE TODAY
Unions and Reunions

New and renewed bonds formed during the 1986 Homecoming remained intact. Pictured here are Josiah Collins VI and Dorothy Redford during his 1989 visit to Somerset Place. He journeyed from Seattle, Washington, to Edenton, North Carolina, to spend some time with his East Coast cousin Frances Drane Inglis.

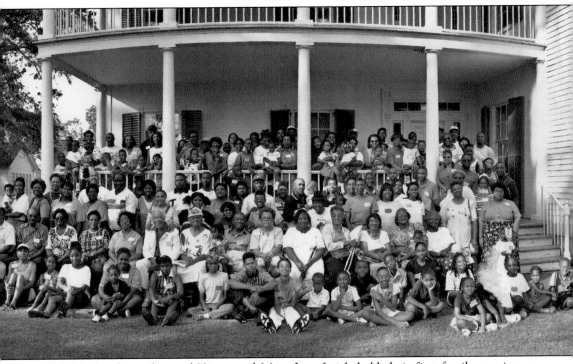

In 1996, the descendants of Hiram and Mary Jane Leigh held their first family reunion at Somerset Place. (Photograph by Doward Jones Jr.)

Attendees at the 1996 event included 65-year-old Haywood McKinley Leigh Sr. and his fabulous and young-looking 91-year-old mother, Sarah Brown Leigh.

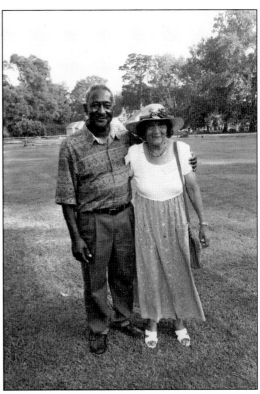

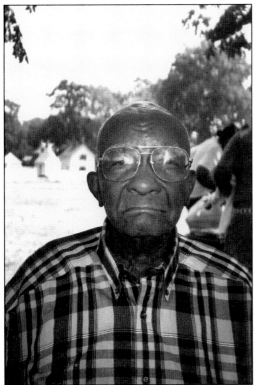

An old African proverb says, "When an elder dies it is as if a library has been burned." Henry Bryant, now a 98-year-old living library, attends all Somerset family reunions.

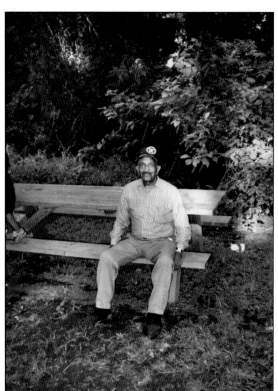

This snapshot of Lora Lee Fanner (1903–2001), called "Daddy Lope," was taken on the grounds of Somerset Place. He was a great outdoorsman who could enchant everyone with stories about his encounters with bears and fishing.

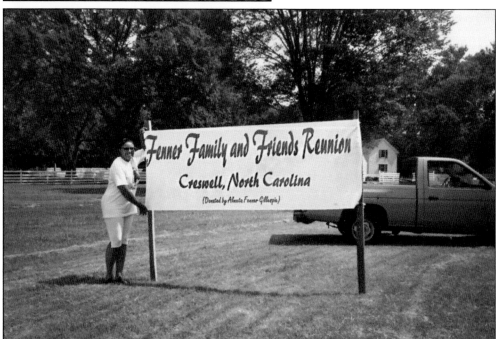

For more than eight years now, the first Saturday in August has been reserved for the Fenner family reunion at Somerset Place. This reunion starts at 5:00 a.m. when a man pulls into the parking lot with his portable cooker and begins the slow cooking of a whole pig.

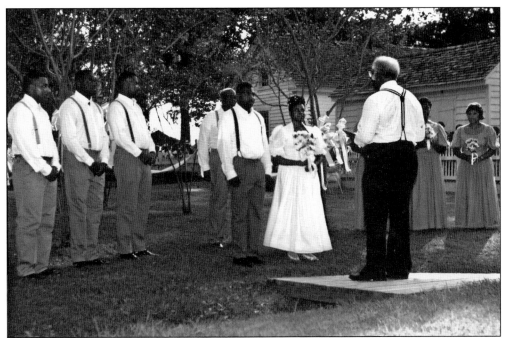

In 1993, Somerset descendant Michelle Riddick exchanged vows with Alfhonso Hudson at Somerset Place with descendant Rev. James Rodgers officiating. Michelle's wedding, attended by all who came to the 1993 Homecoming, culminated with "jumping the broom." (Photograph by Jim Stratford.)

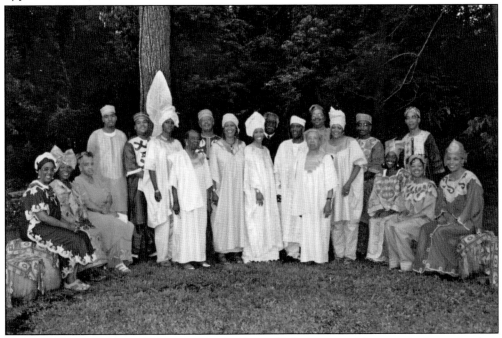

In 2003, Charles Lorenzo Wilson and Leslie Renee Bell chose an Afro-centric theme for their Somerset Place wedding. Charles is a direct descendant of Kofi and Sally, two native Africans brought to Somerset Place in 1786. Again, Rev. James Rodgers is officiating.

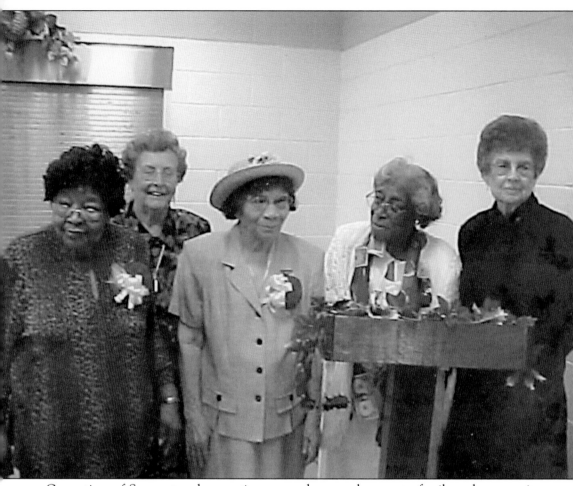

Generations of Somerset and generations everywhere pay homage to family and community elders. Pictured here are five extraordinary women who came together in 2004 to celebrate the 90th birthday of Somerset descendant Mrs. Elsie Reeves Baum—the baby of the group. Somerset descendants, from left to right, are Mrs. Moriah Baum Wills, Mrs. Stathel Spruill (whose father, Renzy Sawyer, helped immensely with the restoration of Somerset Place during the late 1940s), Mrs. Mattie Howell McCrea, Mrs. Elsie Reeves Baum, and Mrs. Esther Ambrose. All are between 90 and 92 years of age. We are grateful to them and for their generation.